CHATHAM NAVAL DOCKYARD & BARRACKS
THROUGH TIME
Clive Holden

AMBERLEY PUBLISHING

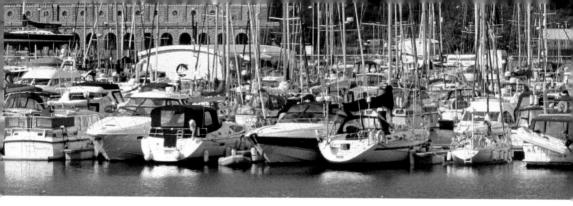

Acknowledgements

I would like to thank the following for their help and kindness in assisting me with the compilation of this book: John Vaughan; Chris Hall; Rex Cadman and Roger Smoothy at 'War & Peace'; Chatham Dockyard Historical Society; Chatham Historic Dockyard Trust (CHDT); and Mark Power.

I must reserve a very special thanks to Helen Crowe of the CHDT for all the time and work she put in on my behalf, searching the dockyard library's vast collection of photographs for me and copying subjects to include here.

First published 2014

Amberley Publishing
The Hill, Stroud, Gloucestershire, GL5 4EP
www.amberley-books.com

Copyright © Clive Holden, 2014

The right of Clive Holden to be identified as the Author of this work has been asserted in accordance with the Copyrights, Designs and Patents Act 1988.

ISBN 978 1 4456 1899 9 (print)
ISBN 978 1 4456 1911 8 (ebook)

British Library Cataloguing in Publication Data.
A catalogue record for this book is available from the British Library.

Typesetting by Amberley Publishing.
Printed in Great Britain.

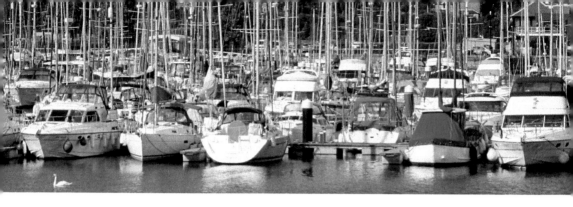

Introduction

In 1547, the last year of Henry VIII's reign, a storehouse was rented alongside the banks of the River Medway at Chatham to store the ropes, masts and other equipment of the royal warships that had, for some years, used the river as a safe anchorage during the winter months. The acquisition of this building marked the genesis of one of the nation's greatest and most important naval dockyards.

In subsequent years, the facilities were expanded to cover an area that was later to be known as Gun Wharf and by the 1570s it had been fully established as a royal dockyard with storehouses, a mast pond, saw pits and a forge. In 1581, a dry dock was completed so ships could be 'graved' to enable their hulls to be repaired and maintained. In 1586, the first vessel to be built at the Dockyard – a pinnace named the *Sunne* – was launched. She was later to be involved in the defeat of the Spanish Armada.

By 1613, the dockyard had outgrown its original location and an area of around 80 acres was acquired to the north of the old yard. Dry docks, wharves, cranes, a sail loft, a ropehouse and officers' residences were built here between 1619 and 1626, by which time the new yard was fully operational. By the end of the century it extended to an area covering most of what is now the site of Chatham Historic Dockyard.

Among the vessels built at Chatham during the eighteenth century was HMS *Victory*, launched in 1765 from the yard's original single dock. She was later to become famous as Nelson's flagship at the Battle of Trafalgar.

Between 1780 and 1830, many of the yard's industrial processes were mechanised. A new double ropehouse was constructed at the southern end of the yard and the famous engineer, Marc Brunel, designed and built a steam-powered sawmill, which, together with its underground

waterway and overhead rail system, automated the handling and sawing of the 12,000 tonnes of timber that the yard consumed each year.

By the mid-nineteenth century, new technologies such as iron and steam had been introduced into shipbuilding at the yard. New slips, docks, workshops and smitheries had been built to handle these new processes, but with the ever increasing size of the Royal Navy and its warships, the demands on the yard were rapidly outgrowing its facilities.

In 1862, work commenced on a massive expansion and modernisation of the yard that added 380 acres to the existing 97. Most of the new work was concentrated on St Mary's Island to the north of the yard. The marshland there was drained ready for the construction of three huge new basins. Eventually five new docks and a new building slip were incorporated into the expansion, together with numerous new workshops, pumping stations, storehouses and a railway system. The major works continued into the early years of the twentieth century, with the new No. 9 Dock being completed in 1903.

That same year the new Royal Naval Barracks, HMS *Pembroke,* opened, replacing the old hulks moored in No. 2 Basin, which, until then, had served as accommodation ships for the seamen from vessels at the dockyard undergoing refits and repairs. When completed, the barracks provided accommodation for 4,700 officers and men, but this figure was more than doubled during wartime. The barracks included a gunnery school, gymnasium and an indoor swimming pool.

In 1905 the new Royal Naval Hospital, built on the Great Lines at Chatham, was opened in great ceremony by King Edward VII. The hospital continued in operational service until 1961 when it was handed over to the NHS.

Chatham Royal Dockyard and Barracks continued to serve the Royal Navy through both World Wars. Although the yard had built its last battleship, HMS *Africa,* in 1905, it was still engaged in the construction of the smaller classes of warships and had also become established as a specialist builder of submarines.

In the 1950s, with the reduction in size of the Royal Navy following the end of the Second World War, the dockyard faced an uncertain future. The workforce were run-down and the yard had been obligated to supplement its work with civilian contracts. The Royal Marines Chatham Division was disbanded in 1950 and their barracks were vacated. In 1958, Gun Wharf, the site of the original Tudor dockyard, was sold. In 1961, the Royal Navy's Nore Command ceased to exist and Chatham was relegated in status to a sub-command of Portsmouth. In 1966, the last vessel to be built at Chatham, the submarine HMCS *Okanagon,* was launched from No. 7 Slip.

The decline was seemingly halted in 1968 with the opening of a new refitting and refuelling facility in No. 1 Basin, giving it a new speciality

for the servicing of the Navy's nuclear-powered fleet submarines. Additionally, the yard continued to be engaged in the refitting and repairing of the smaller classes of surface ships, and was also still home to some vessels of the Reserve Fleet. Despite this new hope for the future, in 1981, the yard's fate was finally sealed when the Secretary of State for Defence announced that the Chatham Base was to close. Even an upsurge in activity during the Falklands War of 1982 could not delay the end.

On 3 June 1983, HMS *Pembroke* held its final ceremonial divisions. On 29 October that year the last commanding officer, Capt. Paddy Sheehan, was ceremonially 'hauled out' of the Main Gate by some of his officers and men, and the barracks fell into the care of the Closure Party.

Meanwhile, on 21 June, the last Royal Naval vessel to be refitted at Chatham, the frigate HMS *Hermione,* sailed out of the Bulls Nose. On 30 September, the yard's closure was marked with an emotional haul down ceremony in front of hundreds of dockyard workers and dignitaries, as well as press and television from all over the world.

On 18 February 1984, the small Barracks' Closure Party gathered at the mast outside the wardroom. The 'Last Post' was sounded by a solitary Royal Marine bugler and the White Ensign lowered for the last time. The party left in a horse-drawn brewer's dray cart and the gates of HMS *Pembroke* were finally locked.

Within a month, Chatham Royal Dockyard too was completely vacated and the Ministry of Defence (MOD) police locked its gates for the last time on the 31 March 1984, thus ending Chatham's 450 year association with the Royal Navy and its ships.

Since the closures, the dockyard and barracks area has been transformed. The University of Kent took over the barracks site and it is now a busy campus, attracting students from all over the world. The oldest part of the dockyard, with its preserved historic buildings, has become one of Kent's major tourist attractions and is known as 'The Historic Dockyard Chatham', while the St Mary's Island site has been redeveloped into a thriving retail and residential area – Chatham Maritime – together with Chatham Docks, which handles merchant ships from across the globe.

With this book I have sought to illustrate many of these huge transformations as well as chart Chatham's important naval heritage and history in photographs.

Clive Holden

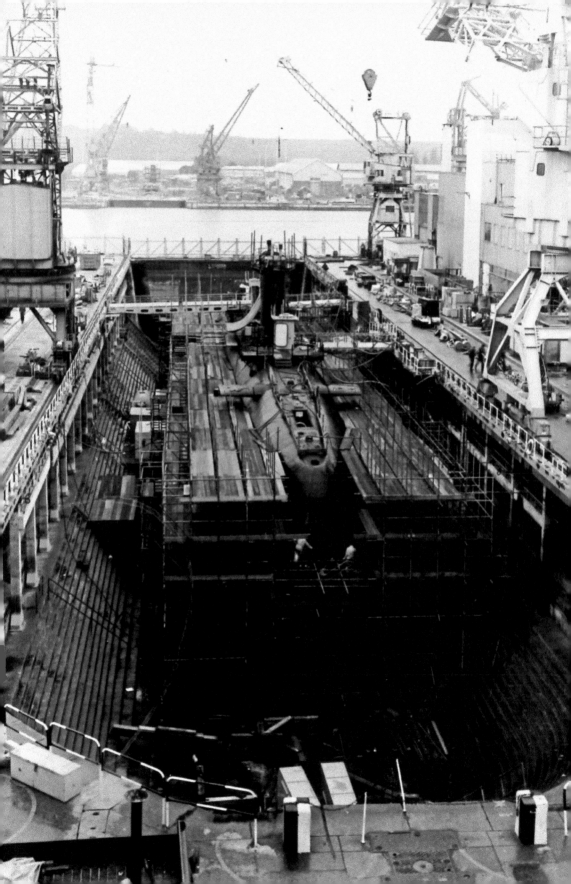

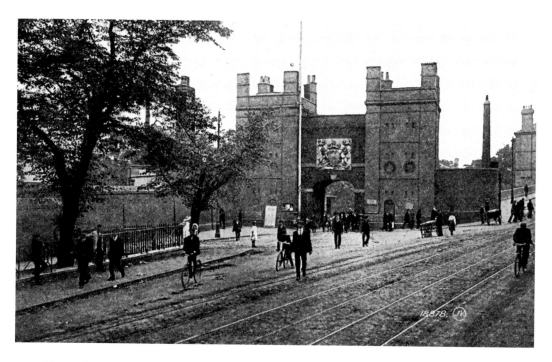

The Main Gate, Chatham Dockyard

Approaching the dockyard from Chatham Town Centre you will be met with the sight of this impressive building. Built in 1722, it not only provided a secure entrance to the dockyard but also provided accommodation for some of the yard's senior employees. It bears the coat of arms of King George III, which was erected on it in 1822 and underwent restoration in 1994 in commemoration of the dockyard's role in support of the D-Day landings.

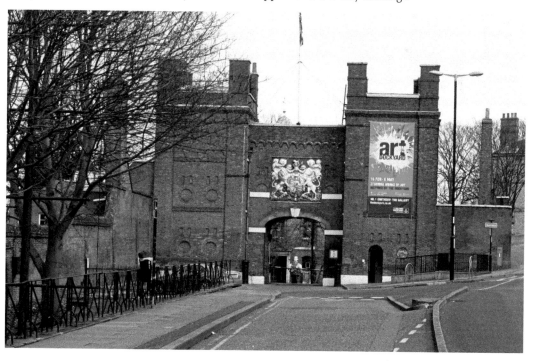

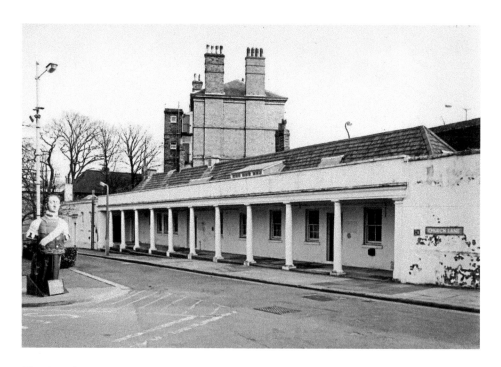

The Guard House

Built in 1764, the Guard House was for the Marine Guards who had been brought in to replace civilian watchmen and warders in an effort to reduce thefts from the yard, which had become a major problem. The original colonnade was made of timber and was replaced in 1815 by the present cast-iron columns. The building was used in later years as administrative and recreation rooms for the Dockyard Police. Today, the building is occupied as commercial premises. (*Photograph above: © Chatham Historic Dockyard Trust*)

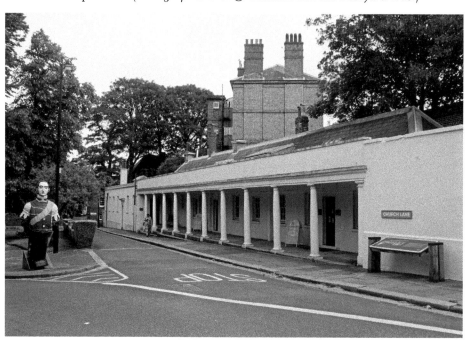

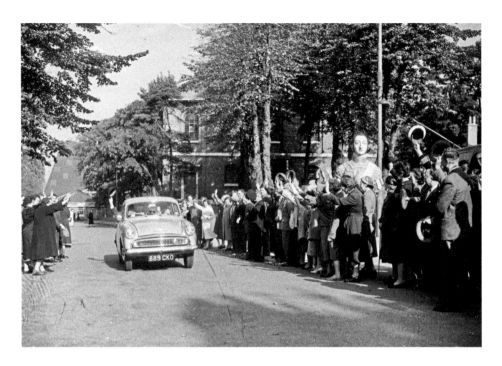

Main Gate Road

This road runs from the Main Gate into the heart of Chatham Historic Dockyard and past the ship's figurehead of HMS *Wellesley*. This 1958 photograph shows Rear Admiral George Verner Motley Dolphin leaving the yard on his retirement as Dockyard Admiral Superintendent. In the background you can see the ornate roof of the No. 2 Covered Slip that was destroyed by fire in 1966. With the exception of the destroyed slip, the view has changed little today. (*Photograph above: © 'The War & Peace Collection'*)

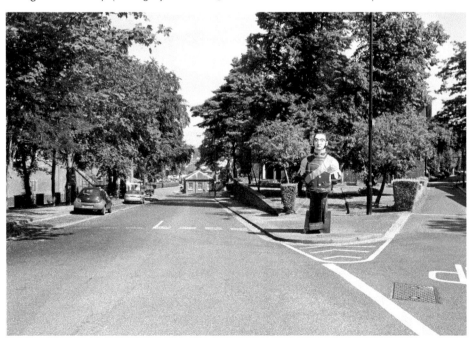

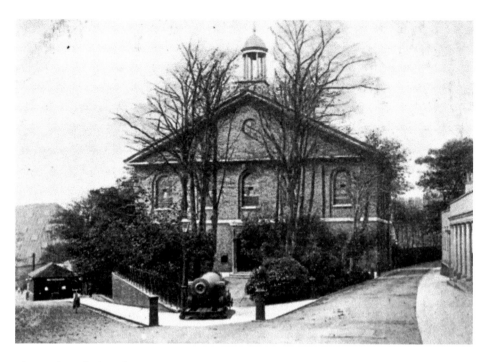

The Dockyard Chapel

Designed by Architect to the Admiralty and Navy Board Edward Holl, and constructed around 1808, the chapel was built in yellow stock brick with details in Purbeck stone. Most of the construction work was undertaken by dockyard workers. The seating was arranged according to rank, which was the cause of some friction in the congregation. Now deconsecrated, the chapel is used as the venue for conferences, presentations and theatrical productions.

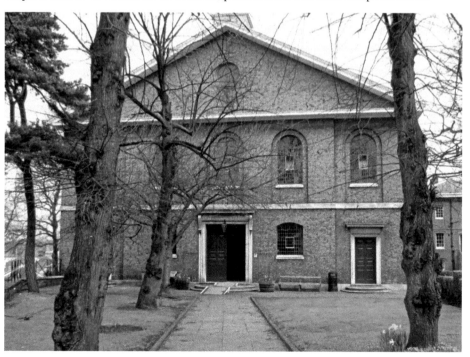

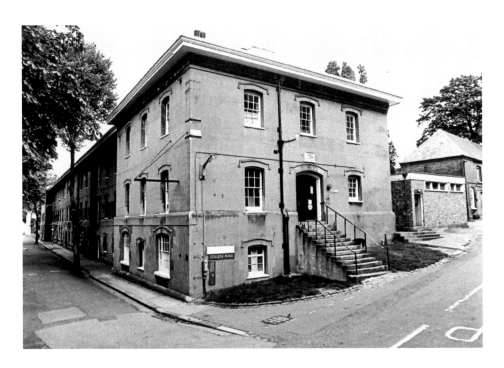

The Sail & Colour Loft

From 1723, the sails for ships built and refitted at Chatham were made in this building. The upper floor provided a large space to lay out the sails as they were made or repaired, while the lower floors provided storage space. During the eighteenth century, 'Ladies of the Flag' were employed to make signal flags. Flag- and sailmaking continued here until 2005. Today the building houses the offices of the Chatham Historic Dockyard Trust. (*Photograph above: © Chatham Historic Dockyard Trust*)

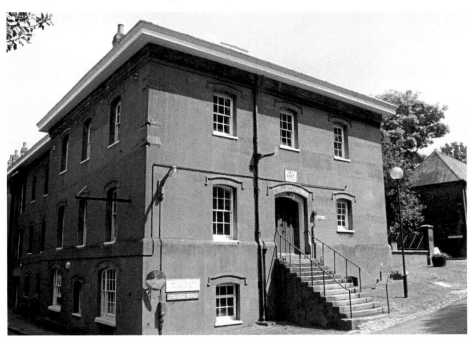

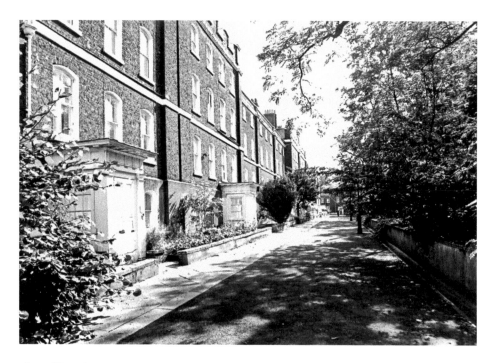

The Officers' Terrace

This impressive row of twelve houses was built in 1722/23 to provide homes for the principal officers of the dockyard. The ground floors provided the offices and the upper floors provided the residential accommodation. Each house had a covered porch that provided a shelter in which visitors' coachmen could wait for them. The houses are now much sought-after private residences. (*Photograph above:* © *Chatham Historic Dockyard Trust*)

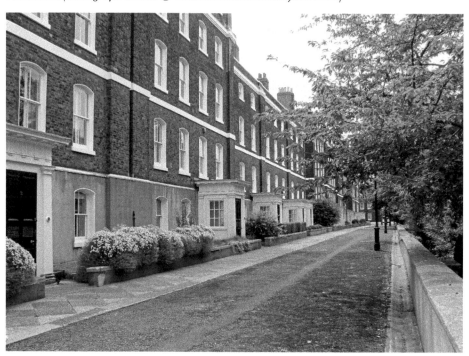

Brunel's Sawmill

Designed by Marc Brunel in 1810, Brunel's Sawmill was connected by a canal and tunnel to the mast pond. The timber was lifted by a floating platform up a shaft. An overhead rail carried it to stores north of the mill, from where it could be retrieved in the same way. Logs were delivered to the mill and converted to planks by eight reciprocating saws in cast-iron frames. It still operates as a sawmill but little of the original machinery remains. (*Photograph above: © Chatham Historic Dockyard Trust*)

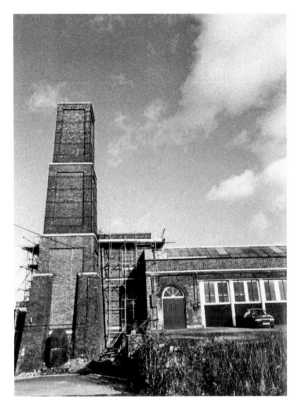

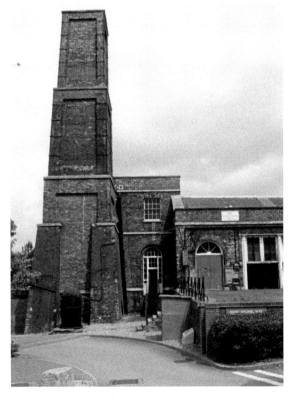

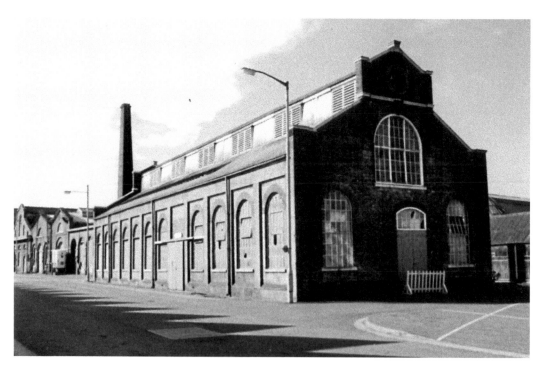

Galvanising Shop

Dating from 1790, this building housed baths of acid and molten zinc, into which steel parts would be dipped to prevent rusting. Following the Royal Navy's departure, it served as Chatham Historic Dockyard's first visitors' centre. It is now used by the University of Kent to host art exhibitions. (*Photograph above: © Chatham Historic Dockyard Trust*)

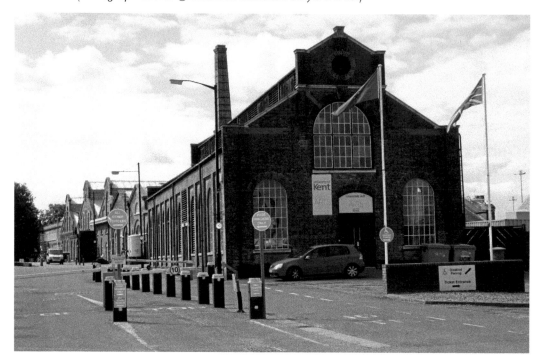

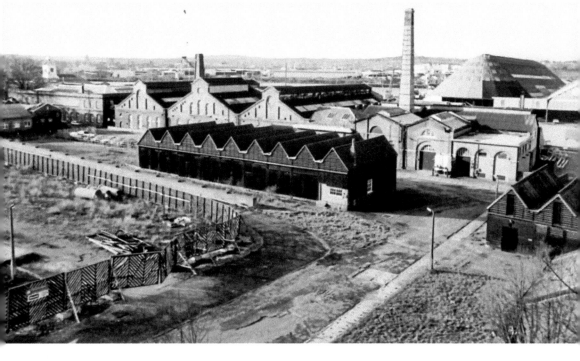

Timber Seasoning Sheds

There are two rows of these sheds at Chatham, consisting of a total of seventy-five bays. In 1771, the Commissioners of the Admiralty Board visited Chatham and were shocked to see how ships constructed from poorly seasoned timber had rotted. Thereafter, plans were made for the construction of timber seasoning sheds at all the various royal dockyards and these were built to a standard design. These sheds at Chatham are the last surviving examples in the country. (*Photograph above: © Chatham Historic Dockyard Trust*)

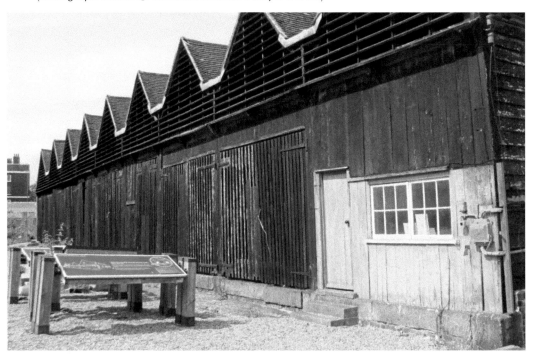

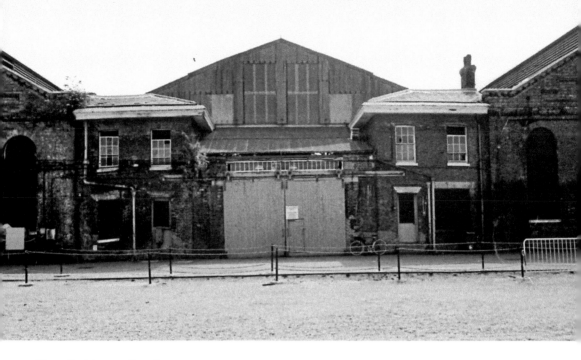

No. 1 Smithery – Exterior

The No. 1 Smithery was designed by Edward Holl and built in 1806–08 to provide the optimum facilities to benefit from the increased use of iron in shipbuilding. The original layout comprised three ranges set around an open courtyard flanked by two small lodges that in turn flanked the courtyard gates. Following major restoration the building reopened in 2010 as a museum and gallery. (*Photograph above:* © *Chatham Historic Dockyard Trust*)

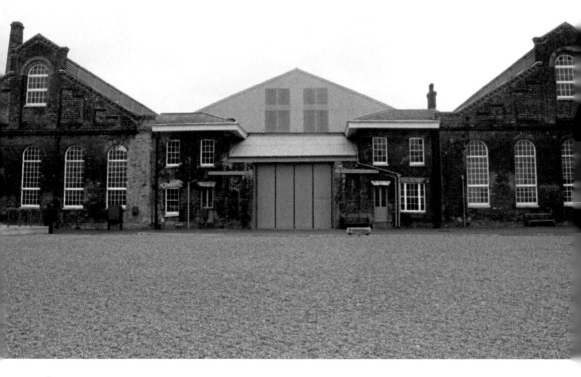

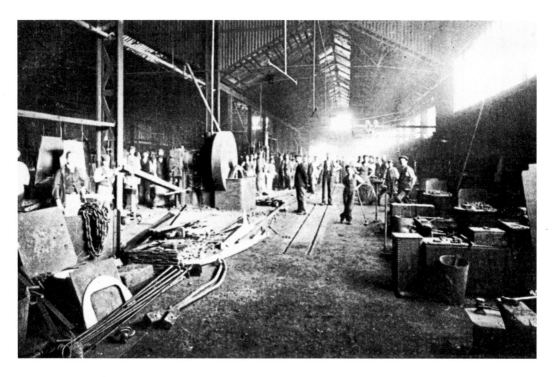

No. 1 Smithery – Interior

This building once housed huge steam hammers and forges, which produced everything from anchors to metal deck beams for the vessels of the Royal Navy that were assembled at the dockyard. The smithery is now home to a new museum and gallery displaying maritime models, art and other objects from various collections.

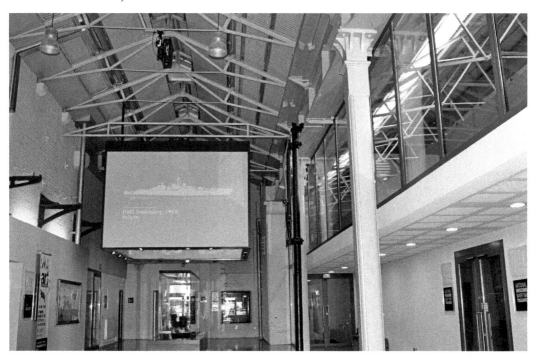

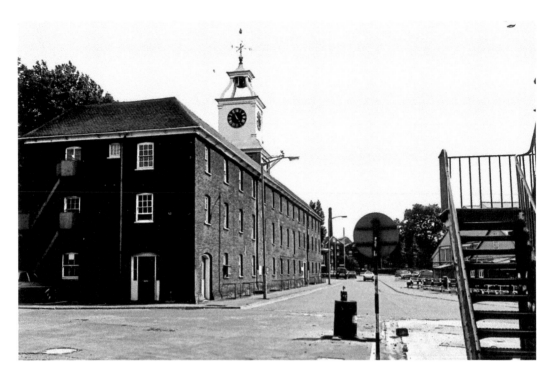

Clocktower Building

Built in 1723, this is the oldest surviving naval storehouse in any of the royal dockyards. The clock tower itself houses an hour bell dating from 1720, and half and quarter hour bells dating from 1820. It was converted into offices in the twentieth century and is now the University of Kent's Bridge Wardens' College. (*Photograph above: © Chatham Historic Dockyard Trust*)

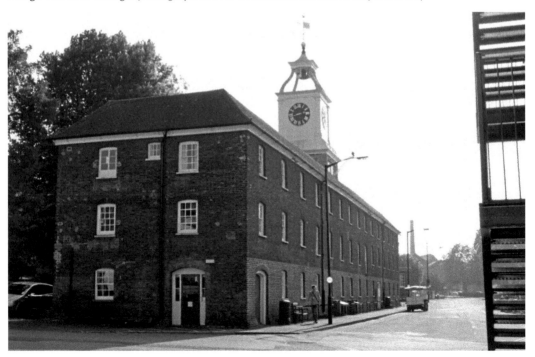

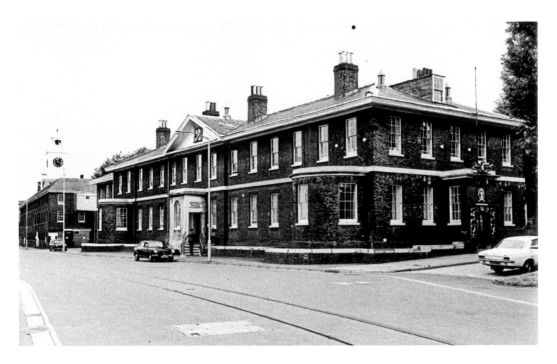

Admiral's Offices

This building was constructed in 1808 to a design by Edward Holl. It was originally used as offices for the yard's master shipwright and other principal officers. It was constructed with a low roofline to avoid obstructing the view from the houses on the Officers' Terrace. It was later extended and served as the port admiral's office and the dockyard communication centre. Today the building is let as commercial office accommodation. (*Photograph above: © Chatham Historic Dockyard Trust*)

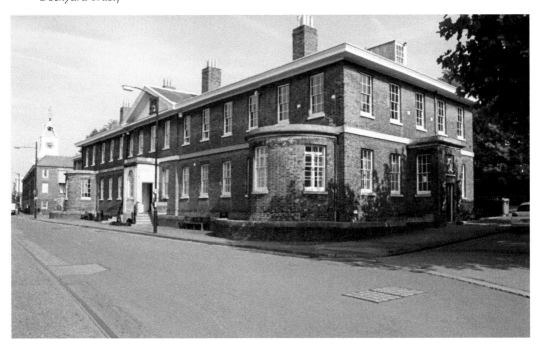

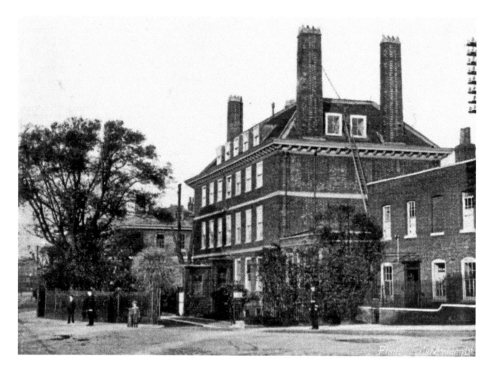

Commissioner's House

This grand residence was built in 1704 and is the oldest surviving naval building in England. Its first occupant was the yard's resident commissioner, Capt. George St. Lo. In later years it was the home of the yard's admiral superintendent and then the port admiral, and was known as Admiralty House. Later, in the 1970s, it was known as Medway House. Chatham Commissioner's House now provides a popular venue for weddings and corporate events.

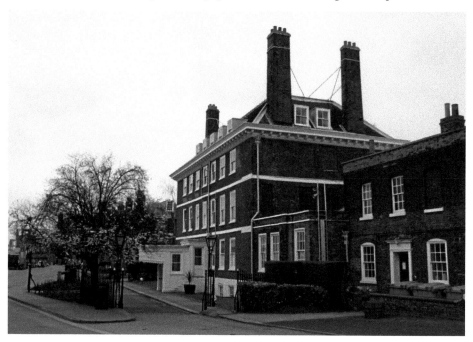

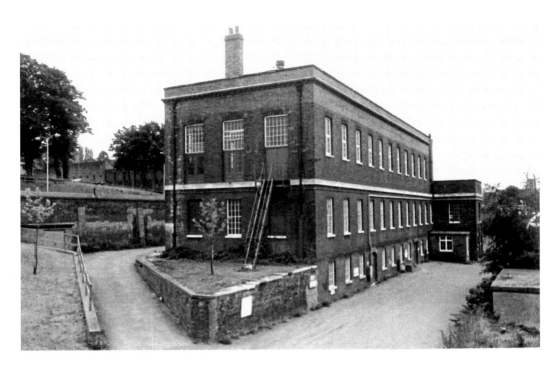

Lead & Paint Mill I

Constructed in 1819, the lead and paint mill originally produced sheet lead, some of which would be further processed into lead oxide. Added to this were dry powder pigments, ground together and mixed with turpentine and linseed oil to produce paint for use on the warships. The mill closed in 1870 because the fumes were causing distress to patients at the nearby Melville Hospital. It was then used as a base for the dockyard painters and an apprentices school. (*Photograph above: © Chatham Historic Dockyard Trust*)

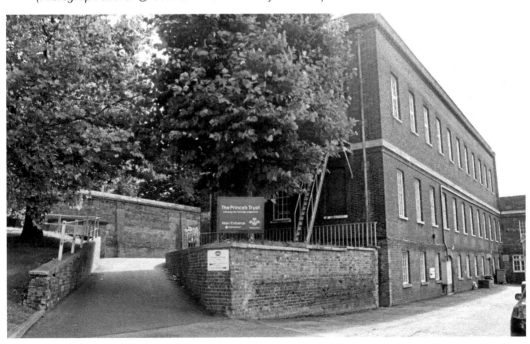

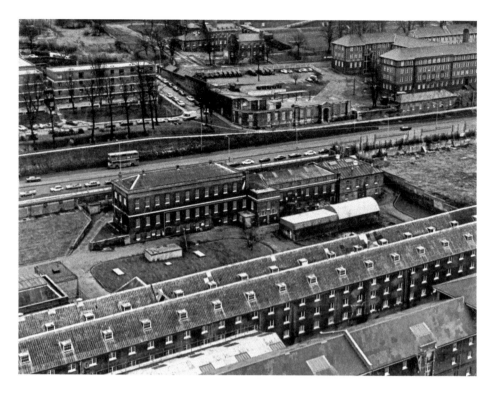

Lead & Paint Mill II

After the Second World War the building became the office of the principal officer and was also used as naval stores, with the upper rooms converted into a secure store for gun sights and other sensitive equipment. Following the dockyard closure, the Chatham Dockyard Historical Society (CDHS) occupied the building, using it as a museum until they moved to their current location in 2001. It is now being used by the Prince's Trust. (*Photograph above: © Chatham Historic Dockyard Trust*)

The Hatchelling House

The Hatchelling House was built onto the north end of the ropery laying floor in 1787 to accommodate the hatchellers who were responsible for the first process of rope-making. In this building they would cut and comb the raw hemp fibres prior to spinning. Today the building serves as the visitors' entrance to the ropery and the adjoining former storehouse is home to the World Ship Society. (*Photograph above: © Chatham Historic Dockyard Trust*)

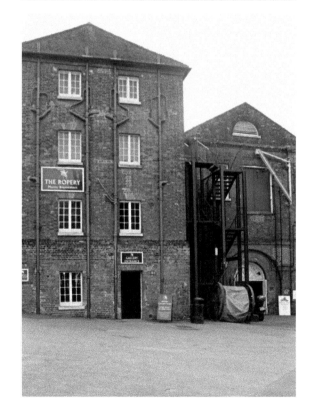

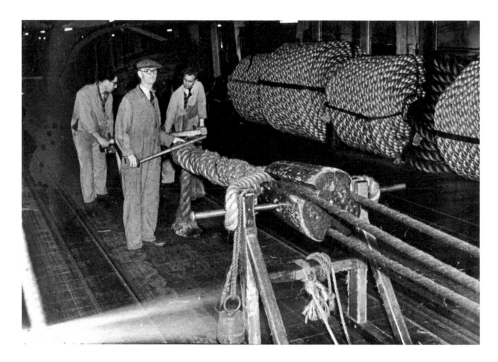

The Ropery

Built in 1791, the double rope house is capable of laying a 1,000-foot rope – a process that originally required over 200 men to complete. In 1826, a steam-powered beam engine was installed to drive the machinery and in the 1900s electrical power was introduced. The ropery now manufactures rope commercially, using much of the original machinery, and it is also one of Chatham Historic Dockyard's main visitor attractions. (*Photograph above:* © *'The War & Peace Collection'*)

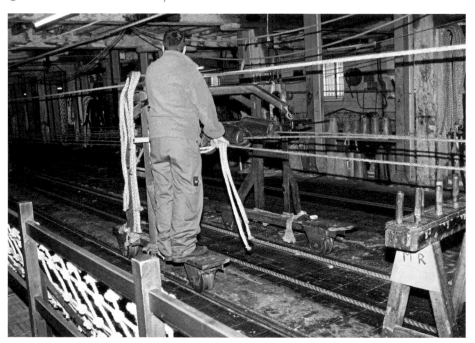

Anchor Wharf Storehouses

These two riverfront storehouses, built between 1778 and 1805, were the largest storehouses ever constructed for the Royal Navy. The southernmost building, Storehouse No. 3, was a 'lay apart' store where equipment from each ship under repair or reserve in the dockyard could be kept together. The northernmost building incorporated Fitted Rigging House No. 1 and Storehouse No. 2. The rigging house stored miles of ship's ropes and rigging. This building now houses the dockyard's museum and library. (*Photograph above: © Chatham Historic Dockyard Trust*)

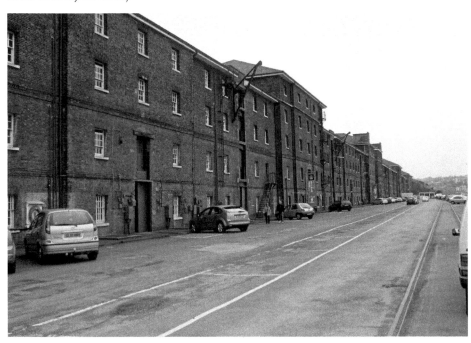

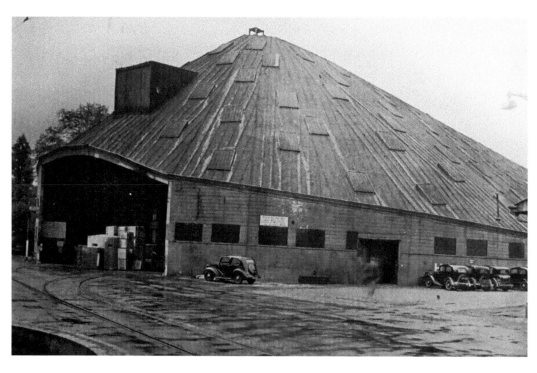

No. 2 Slip

Seen here in the 1930s, No. 2 slip was built in 1770 and was covered by a handsome mansard roof in 1837. It was destroyed by a devastating fire in 1966. The cause of the fire was never known. Stored inside and around the slip were several historic ships' figureheads, most of which were also destroyed in the fire. The site now serves as a car park for those working in the nearby buildings.

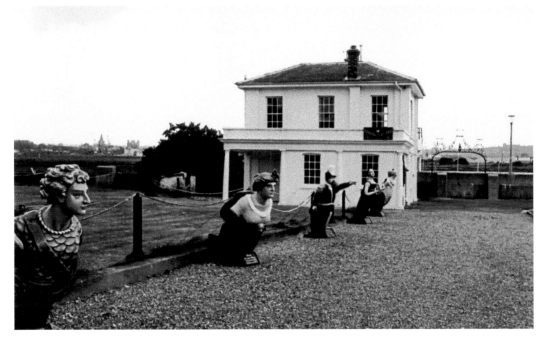

Assistant Queen's Harbourmaster's Office

Built in 1770, this building was the office of the dockyard's two master attendants who were responsible for the ships moored in the River Medway. During the nineteenth century the job was taken over by the King or Queen's Harbourmaster and the duties performed by his assistant working from this building. In more recent years it has been used for a time as a social club for those working in Chatham Historic Dockyard. (*Photograph above: © Chatham Historic Dockyard Trust*)

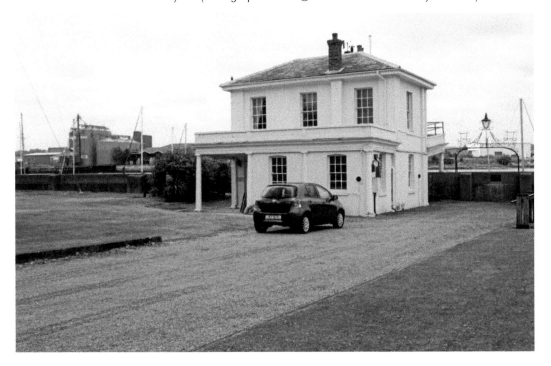

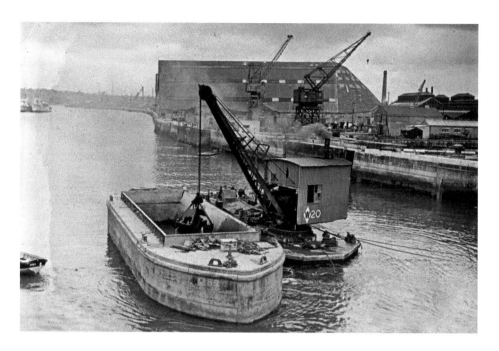

Riverfront

The build-up of mud and silt along the Medway was a continual problem for vessels still needing to access the docks and wharves in the older part of the Dockyard in the twentieth century. Dredging operations, such as seen in this 1960s photograph, were necessary to keep the channels clear. The river frontage here remains virtually unchanged with its views of the dock caissons (watertight gates) and No. 3 Slip. (*Photograph above: © 'The War & Peace Collection'*)

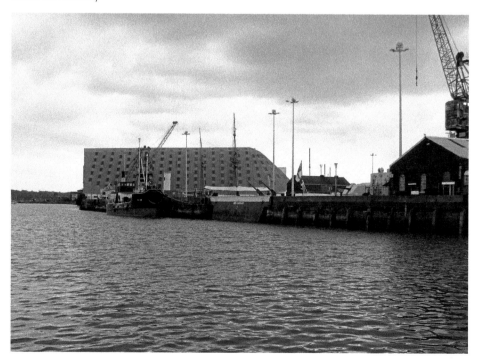

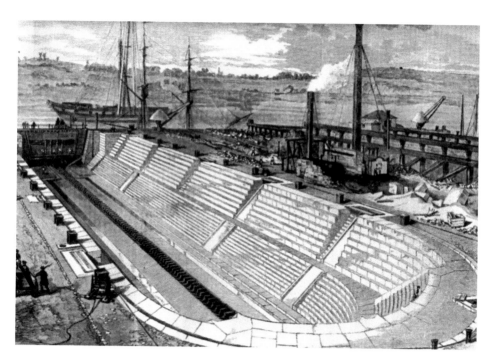

No. 2 Dock

Completed in 1856, No. 2 Dock was built on the site of the old 'Single Dock', in which Nelson's famous flagship HMS *Victory* had been built. In 1863 Britain's first iron battleship, HMS *Achilles,* was constructed in the new dock. The dock is now the home of the Second World War destroyer, HMS *Cavalier,* berthed here as a museum ship and open for the public to tour around.

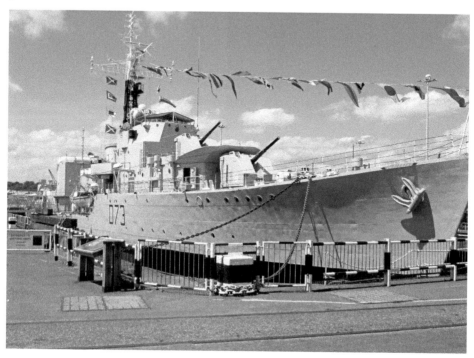

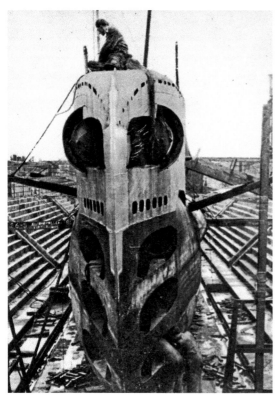

No. 3 Dock

No. 3 Dock was the first stone dock to be built at Chatham. Completed in 1821, it was filled via sluice gates set into the caisson. Vessels could enter the dock and be secured, the caisson closed and the water pumped out, leaving the vessel supported on blocks, enabling work to be carried out on it as in this 1940 photograph. The dock is now the home of the submarine HMS *Ocelot*, one of the dockyard's collection of historic ships.

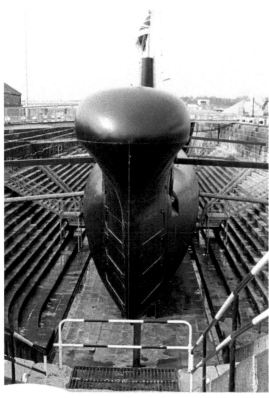

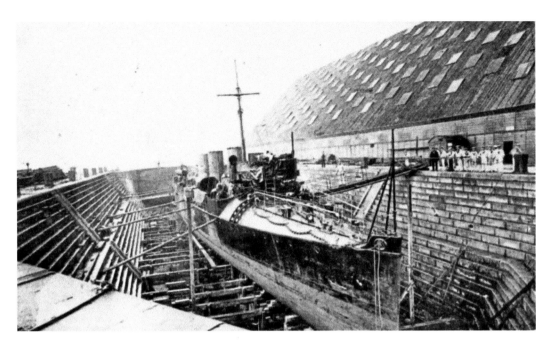

No. 4 Dock

Completed in 1840, No. 4 Dock was formed by lengthening and deepening the old No. 3 Dock and lining it in stone. In the picture above we see the destroyer, HMS *Greyhound,* undergoing repairs in the dock in the early 1900s. Today the dock is home to HMS *Gannet,* a museum ship, and is part of the National Historic Fleet Core Collection.

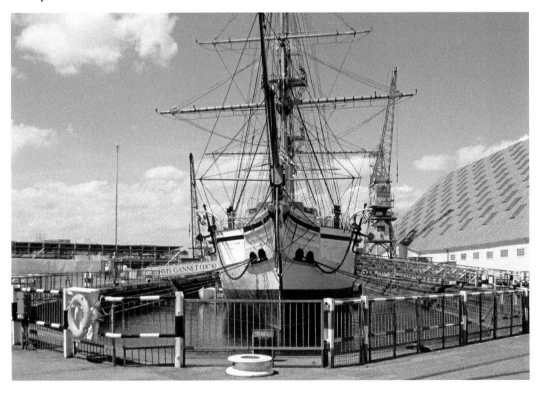

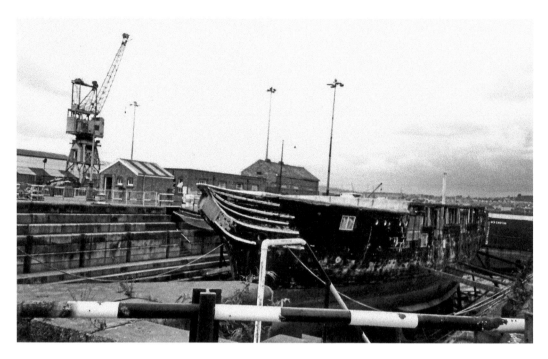

HMS *Gannet*

In 1987 Chatham Historic Dockyard chartered the hulk of the former Royal Navy sloop, *Gannet*, from the Maritime Trust, in order to restore her to her original appearance. Launched in 1878, during her career she performed in a number of roles including an anti-slavery ship, a training ship and an accommodation hulk. Seen here in No. 3 Dock shortly after her arrival in 1988, she is now moored in No. 4 Dock, looking much as she did in 1888.

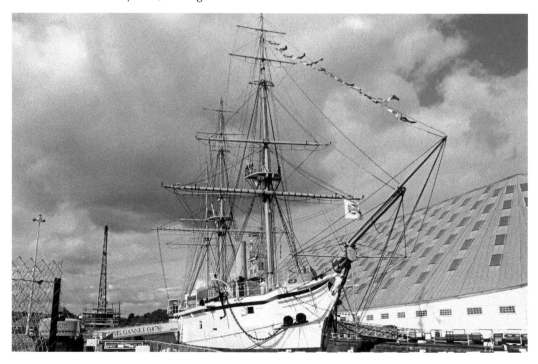

South Dock Pumping Station

Built in 1822, this was Britain's first steam-powered pumping station. It originally housed Boulton & Watt beam engines, which were replaced in 1929 with electric pumps. The building consists of a central boiler house with a chimney and two adjoining engine houses. The station was used to empty water from the three nearby docks into the Medway by way of underground culverts and is still capable of operation today. (*Photograph above: © Chatham Historic Dockyard Trust*)

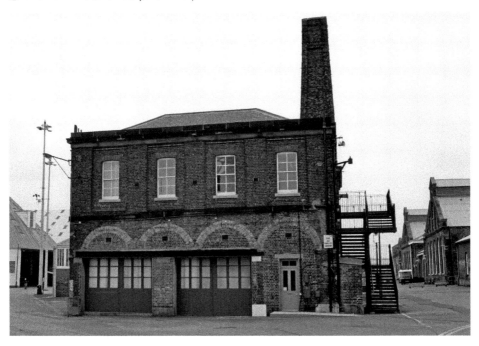

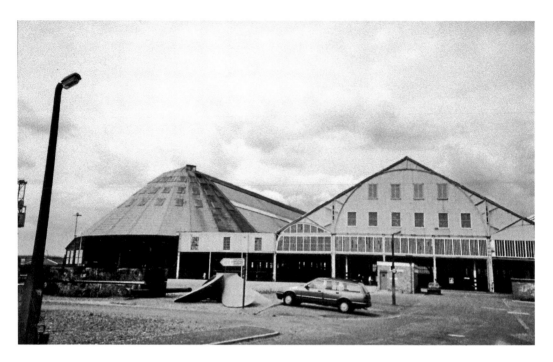

The Covered Building Slips

Vessels were originally constructed in open docks and slipways. Exposed to the elements, many of the wooden ships built in them rotted before they even launched, so in the nineteenth century a programme commenced to roof over the existing and build new covered slips. Nos 3 and 4 Slips can be seen above empty in 1988, a few years after the yard's closure. No. 4 Slip now houses the RNLI's collection of historic lifeboats and is a popular visitor attraction.

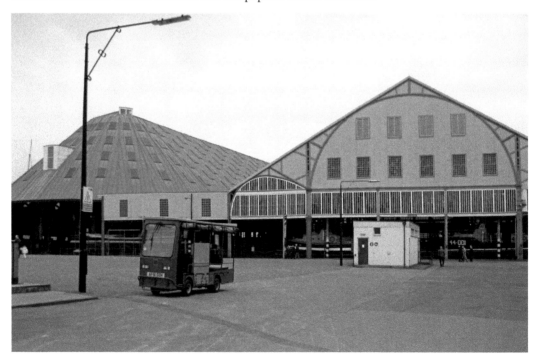

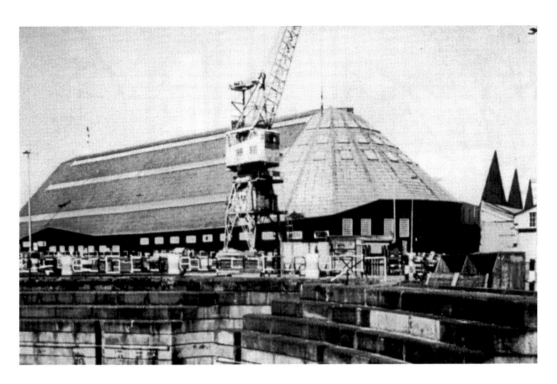

No. 3 Slip – Exterior

One of the most beautiful and architecturally interesting buildings in the dockyard, No. 3 Slip was built in 1838 and at that time was Europe's largest wide-span timber structure. Its weatherboarded walls are covered by a wonderful large mansard roof. It is seen above in the early 1980s and below as the scene is now. (*Photograph above: © Chatham Dockyard Historical Society*)

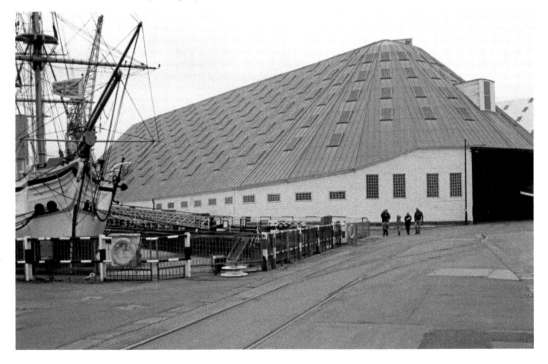

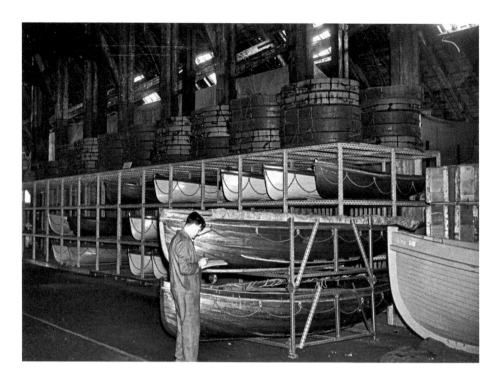

No. 3 Slip – Interior

When it ceased to be used for building, the slipway was infilled and in 1901 a steel mezzanine floor was added when the building was adapted for use as a boat store. The timber-framed interior of this slip is every bit as impressive as the exterior and its spectacular roof space now provides a venue for cinema viewing, private functions and meetings, while the ground floor is home to some of the dockyard's largest museum exhibits. (*Photograph above:* © *'The War & Peace Collection'*)

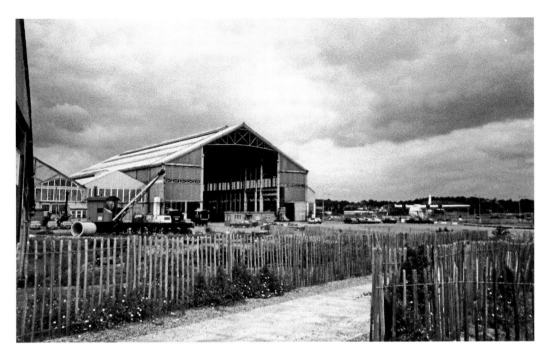

No. 7 Slip

Built in 1852–55, this is the largest of the dockyard's surviving covered slipways. The last vessel built at Chatham, the submarine HMCS *Okanagon* was launched from here in 1966 and commissioned into the Royal Canadian Navy. In 1988 the slip was empty, but outside stood a Short Sunderland flying boat that was undergoing restoration at the time. Today the slip is once again an active boatyard offering repair and maintenance facilities for barges, riverboats and other similar craft.

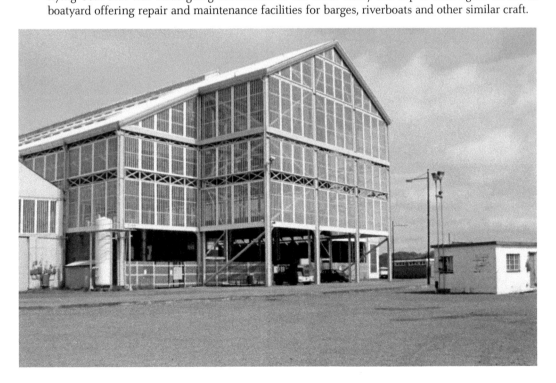

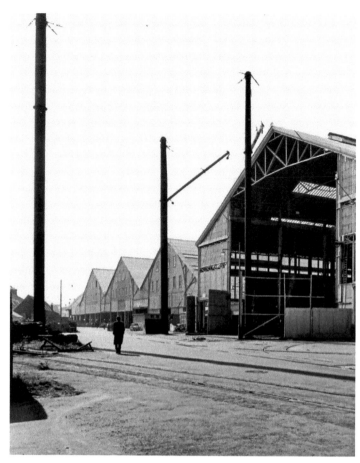

No. 7 Slip – Extension
By the late nineteenth century, warships were increasing in size and outgrowing Chatham's building facilities. Pending completion of the new No. 8 Slip, a short-term solution was found by erecting gantries in the yard outside No. 7 Slip, extending the slipway by over 70 feet. The extension gantries were still in place in the 1957 photograph above but little sign remains today apart from some evidence of their concrete bases, which can still just be seen in the car park. (*Photograph above:* © *Chatham Historic Dockyard Trust*)

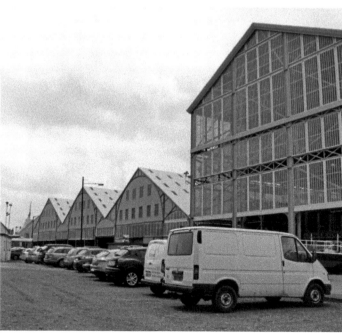

Wheelwrights' Shop

Built in 1780, the wheelwrights' shop had three bays. The western bay, seen in these photographs, was used for making capstans, which ships then used to raise and lower anchors. The central bay was used for making pumps, pins and bearings. The eastern bay was used for the building and repair of wheels for the many carts and wagons in use in the dockyard. The building now houses a fully licensed restaurant used by those visiting and employed in the dockyard. (*Photograph above: © Chatham Historic Dockyard Trust*)

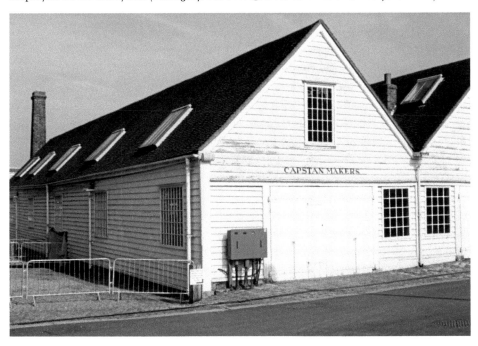

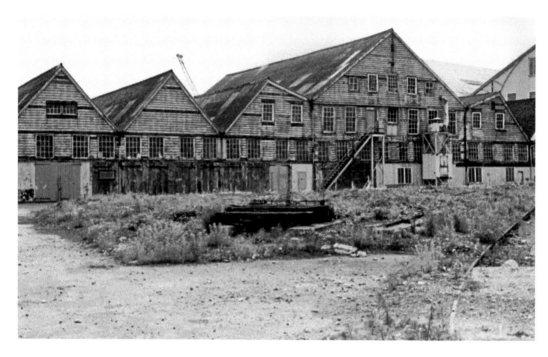

Mast House & Mould Loft

Built in 1753–55, this building had two uses. The ground floor was used to shape and store ships' masts, while the first floor was used by shipwrights and naval architects to lay out the lines of ships to be constructed in their full dimensions from which wooden moulds could be made to shape their frames. The building now houses the dockyard's shop and visitors' centre and provides a large space for special exhibitions. (*Photograph above: © Chatham Historic Dockyard Trust*)

Lower Boathouse

Constructed in 1844, originally as a shed to store squared timber, the lower boathouse was later adapted to become a storehouse and workshop for ship's boats. It is now regarded as the best example of only three such surviving naval boathouses in the country (the other two being at Portsmouth) and is still in use by local companies, including some boatbuilders. (*Photograph above: © Chatham Historic Dockyard Trust*)

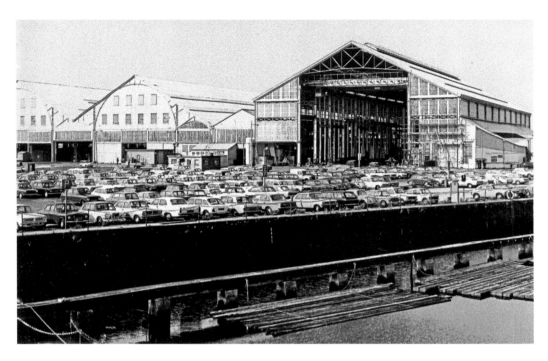

Mast Ponds

The dockyard had two mast ponds, in which lengths of timber were stored in salt water to evenly season and prevent them from cracking before being made into masts. The South Pond was filled in during the nineteenth century and the site was later used for car parking, as seen in the 1970s photograph above. In the foreground are some timber lengths floating in the North Pond. The South Pond site is now a car park for visitors to the Historic Dockyard. (*Photograph above:* © *Chatham Dockyard Historical Society*)

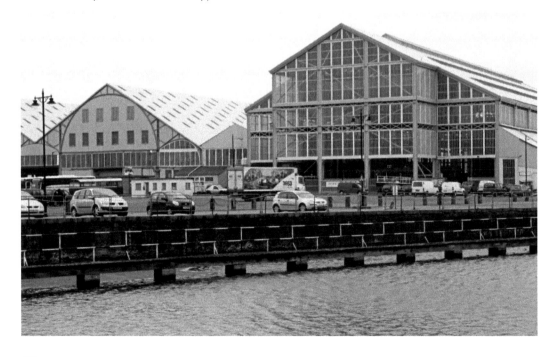

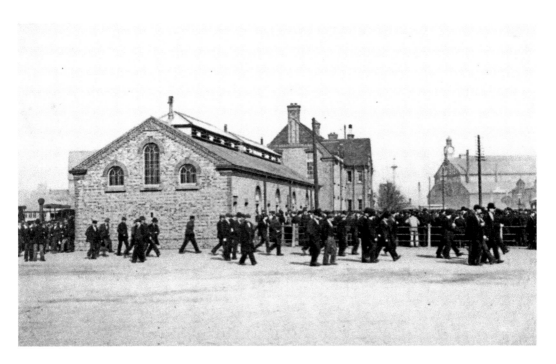

Pay Office

Every Friday morning the dockyard bell would be rung to summon the dockyard workers to the pay office to collect their wages. The office in the above photograph was built when the dockyard expanded in the late nineteenth century to replace the old pay office, which was situated in the Georgian part of the yard. The buildings pictured have long been demolished but the distinctive clock tower of No. 1 Boiler Shop can still be seen in the distant background.

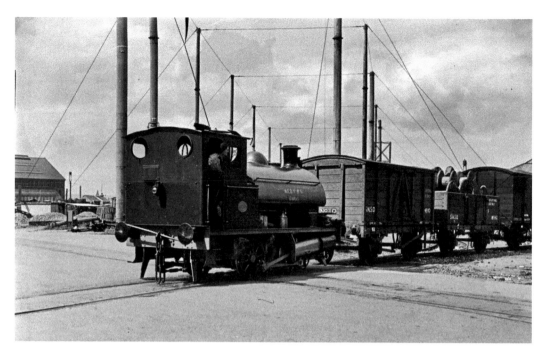

No. 8 Slip I

No. 8 Slip was the largest of Chatham's slips and the only one to remain uncovered. It was built in 1900 to accommodate the construction of the larger classes of warships then coming to the fore. Its historic significance was immense, having been used to build Chatham's largest and last battleship, HMS *Africa*, in 1905. The area through which a dockyard train is seen passing in front of the slip is now a car park for the dockside shopping centre. (*Photograph above:* © *'The War & Peace Collection'*)

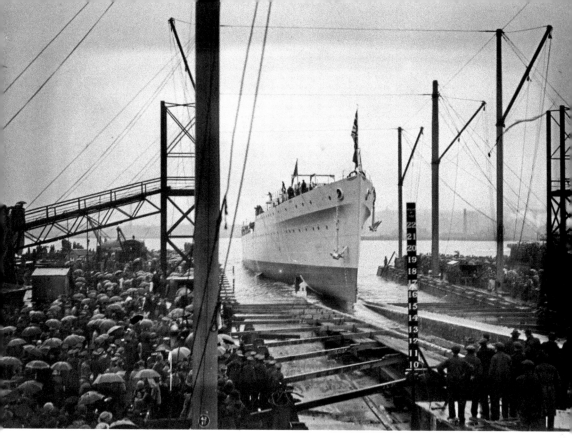

No. 8 Slip II

Another view of the slip, featuring the launch of the cruiser HMS *Arethusa* in the rain on 6 March 1934. A large throng of dockyard workers and specially invited guests are crowded around the sides of the slipway as the vessel enters the Medway. The slip was demolished and infilled in 1992, as construction work pressed ahead on the Medway Tunnel and its approach road. The site is still derelict and awaiting redevelopment. (*Photograph above:* © *'The War & Peace Collection'*)

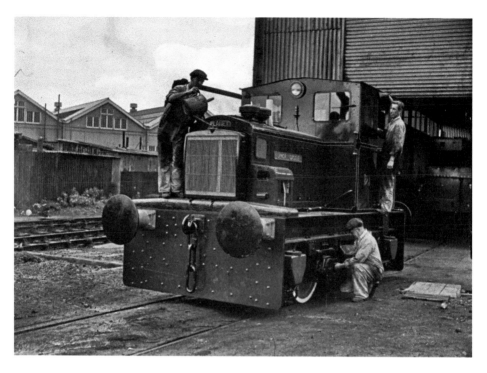

Dockyard Railway Engine Shed

This photograph from the 1950s shows one of the dockyard's diesel locomotives, *Upnor Castle*, undergoing some maintenance in the yard's engine shed. The engine shed was demolished after the dockyard's closure, with the site now occupied by a delivery area for the dockside shopping centre and the approach road to the Medway Tunnel. (*Photograph above: © 'The War & Peace Collection'*)

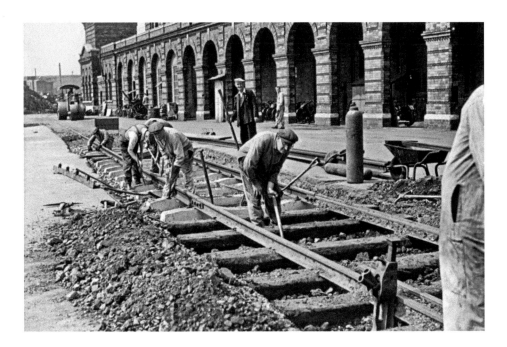

The Dockyard Railway

The development of a railway system began in the 1860s with the introduction of a narrow gauge tramway connecting the various machine shops, the sawmill, the docks and the slips. In 1873, powers were sought for the construction of a standard gauge branch line into the dockyard, which opened in 1877. The new standard gauge branch line (see page 48) reached the dockyard at the Gillingham Gate. From here the military extended it into the new area of the dockyard, fanning out into all areas of the yard and extending into the neighbouring Gun Wharf. In the 1960s, the original wooden sleepers were being replaced with concrete around No. 1 Basin. The above photograph shows platelayers replacing old sleepers under the tracks alongside No. 5 Dock Pumping Station in the 1960s. No trace of these tracks remains now. (*Photograph above: © 'The War & Peace Collection'. Photograph on page 48: © 'The War & Peace Collection'*)

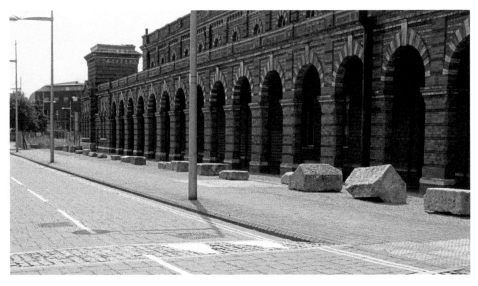

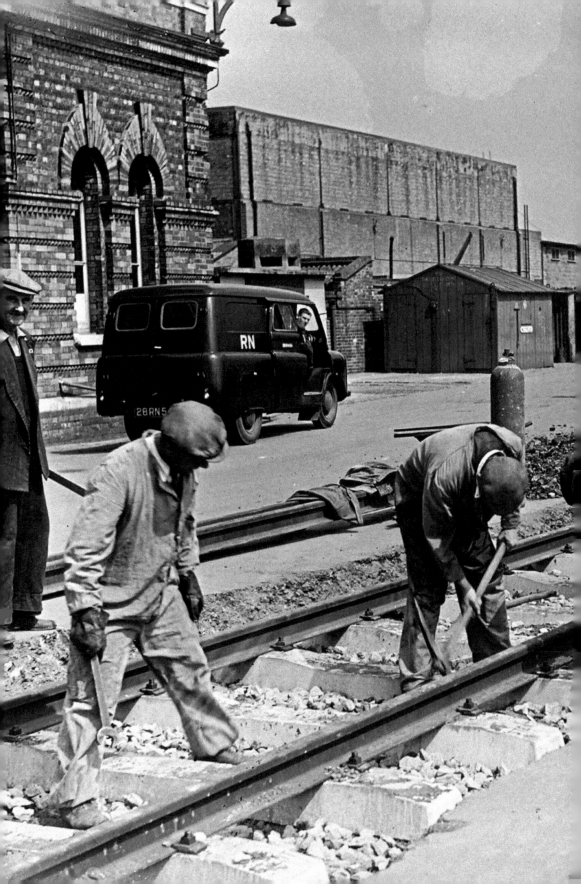

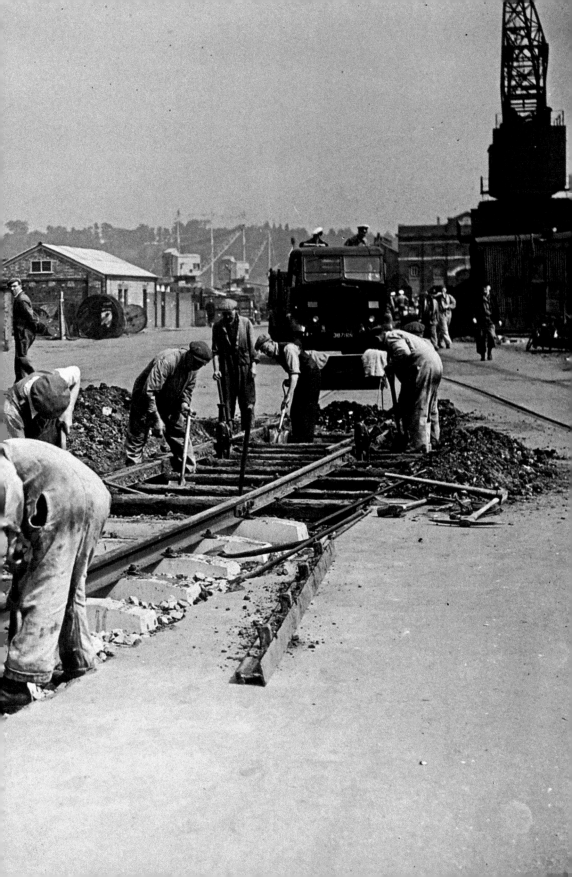

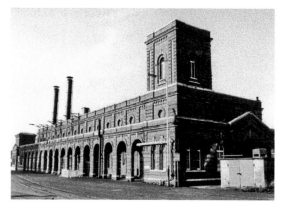

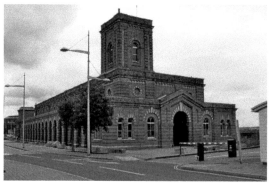

No. 5 Dock Pumping Station I
Constructed in 1873 as part of the
dockyard extension, this magnificent
building provided the power to drain
four of the new docks in No. 1 Basin
via an extensive network of deep brick
culverts. It fell into disuse and disrepair
soon after the top photograph was taken
following the dockyard's closure in 1984.
The building has recently been restored
but none of its machinery survives inside.
(*Photograph left and above: © Chatham
Historic Dockyard Trust*)

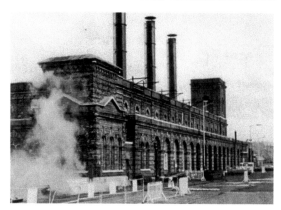

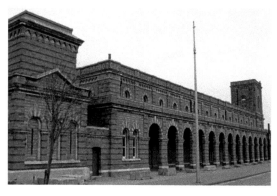

No. 5 Dock Pumping Station II
The station was originally steam-
powered and had a magnificent tall brick
chimney, which emerged from the plinth
on the roof seen in the foreground of the
1970s photograph left and above. The
steam pumps were replaced by diesel-
electric pumps after the Second World
War and the chimney was demolished
to be replaced by the ugly steel 'tubes'
seen here. The steel chimneys no longer
remain, leaving the building looking
much as it was originally intended.
(*Photograph left and above: © Chatham
Dockyard Historical Society*)

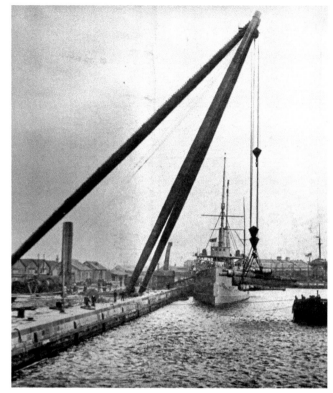

The 'Giant Sheers'
This huge 180-tonne tripod hoist was installed in the early 1900s on the north side of No. 1 Basin. It enabled many opportunities, including the heaviest guns to be raised and transported from the quay to the warship's deck with ease, as can be seen in this 1905 photograph. The hoist was demolished in the 1950s and no trace of it or the nearby buildings remain, with the site being redeveloped for housing.

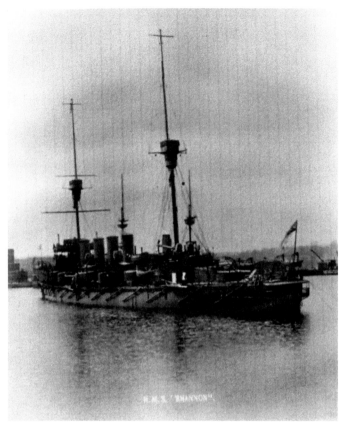

No. 1 Basin (Looking West)
Also known as the Repairing Basin, this was the first basin of the Victorian dockyard extension to be completed. It was officially opened in June 1871 and covered an area of over 20 acres. It was finally completed in 1873 and was equipped with five dry docks. The cruiser HMS *Shannon* is seen here moored in the basin in 1908. The basin is now the home of Chatham Maritime Marina with berths for 370 leisure craft.

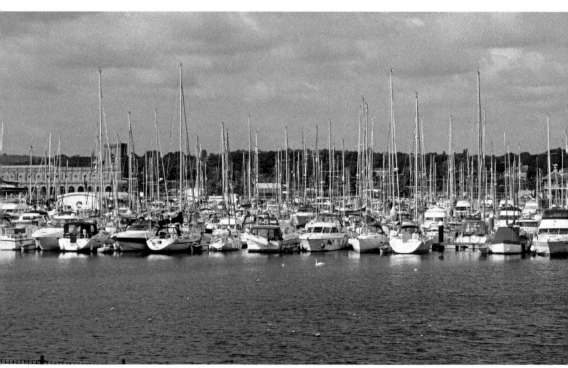

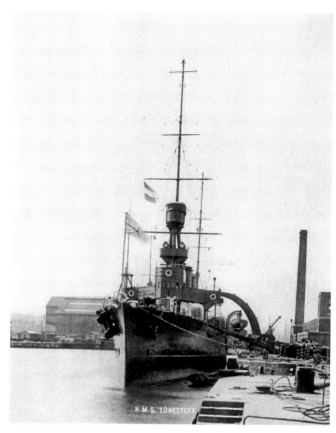

No. 1 Basin (Looking South)
The basin originally had an entrance out onto the Medway opposite Upnor, but this was later sealed. The light cruiser, HMS *Lowestoft*, is seen here around 1920, moored near this entrance. In the right background No. 5 Dock Pumping Station is visible, with its magnificent original chimney. Today the Upnor entrance has been reinstated, allowing access to and from the Medway for boats using Chatham Maritime Marina.

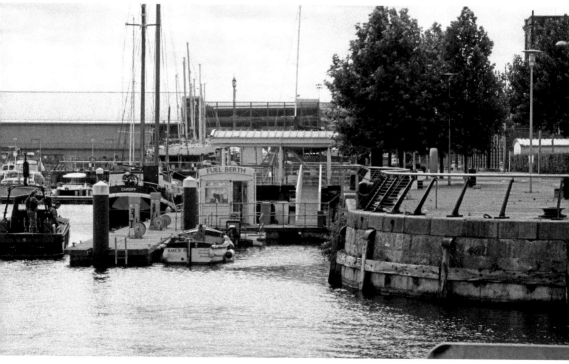

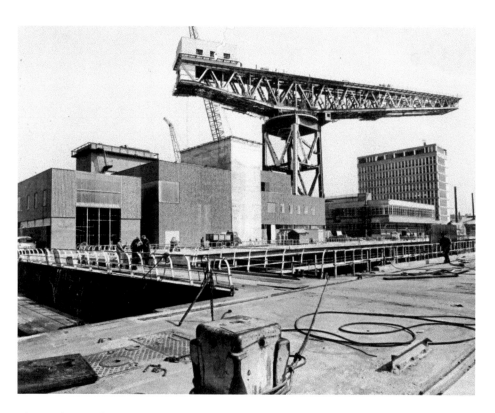

The Nuclear Refitting Complex

Opened in 1968 and situated between Nos 6 and 7 Docks, the complex refitted and refuelled the Royal Navy's nuclear-powered Fleet Submarines. Between 1970 and 1983 nine major refits were completed, plus many minor refits and works. The monster 1,700-tonne complex crane towered to a height of over 100 feet and was an impressive local landmark. The complex was demolished following the dockyard's closure and the site now houses a restaurant and quayside apartments. (*Photograph above:* © *Chatham Historic Dockyard Trust*)

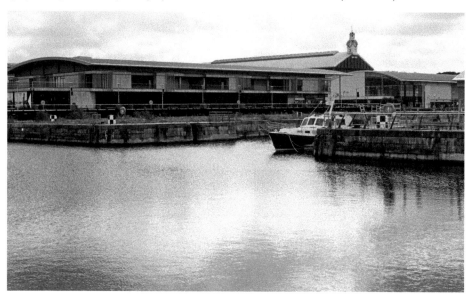

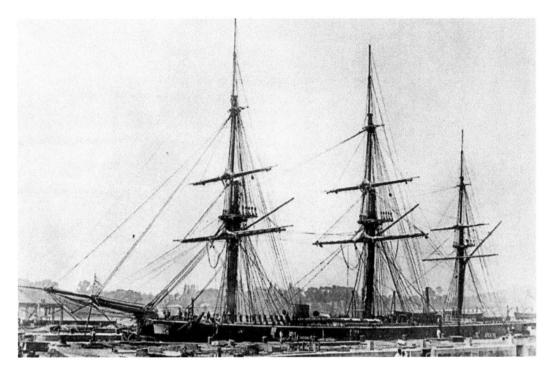

No. 5 Dock

No. 5 Dock was the first dock completed in No. 1 Basin. It was put to use in June 1871 when the battleship HMS *Invincible*, seen above, entered it amid great ceremony. Hence the dock was originally known as the 'Invincible Dock' until it was later redesignated No. 5 Dock. Today the dock is permanently flooded and the area adjacent to it is used as a boatyard by Chatham Marina.

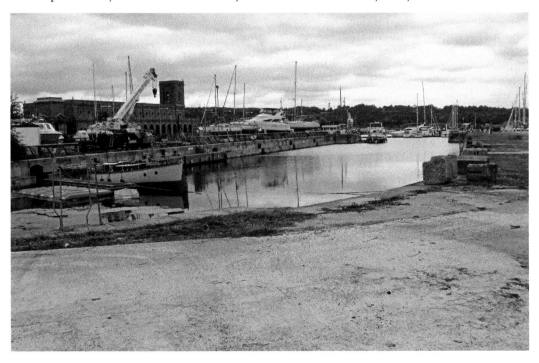

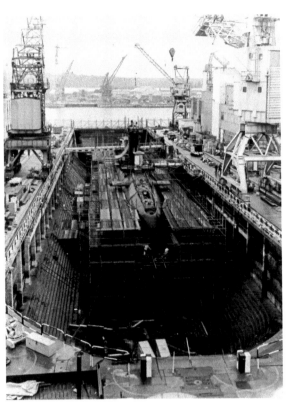

No. 6 Dock

No. 6 Dock was the second dock to be completed and, with a length of 418 feet, was the shortest in No. 1 Basin. From 1968 the dock formed part of the Nuclear Refitting Complex and the submarine, HMS *Churchill,* can be seen refitting in the picture to the left in the early 1980s. She was the last boat to be refitted in the complex before the yard's closure. Today the dock area is fenced off, and the land between it and No. 5 Dock remains derelict. (*Photograph above:* © *Chatham Historic Dockyard Trust*)

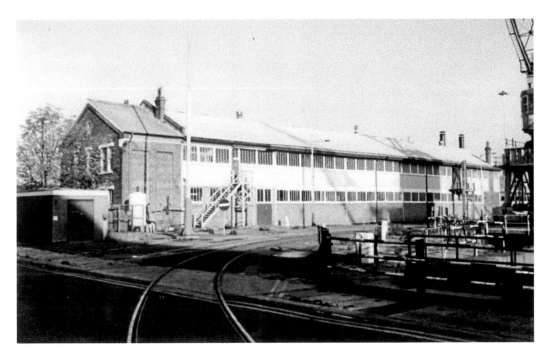

No. 6 Machine Shop

Situated between Nos 6 and 7 Docks, this large building was a workshop that housed machine tools used for the maintenance of vessels in the dry docks for repair and refit. It was demolished in the 1960s to make way for the Nuclear Refitting Complex. Today a different complex, consisting of apartments and a restaurant, now stands on the site. (*Photograph above:* © *Chatham Historic Dockyard Trust*)

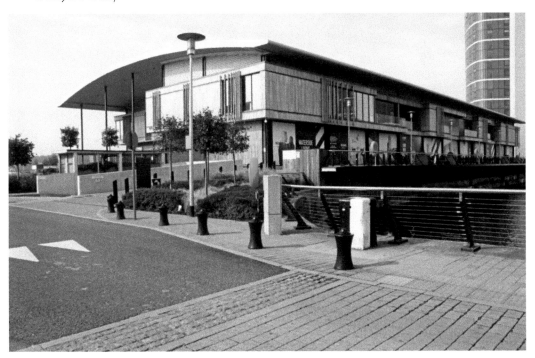

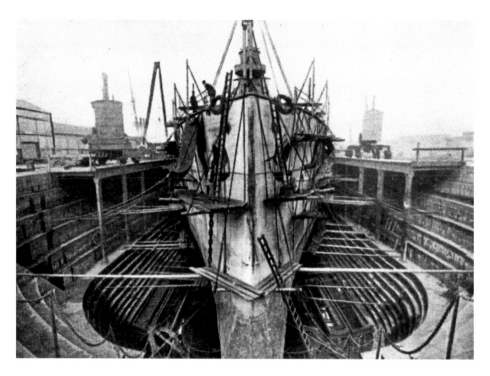

No. 7 Dock

Another one of the five new docks constructed in No. 1 Basin. No. 7 Dock was completed in 1872 and with a length of 428 feet was able to handle the larger warships of the period. Seen here in the dock around 1903 is the battleship HMS *Prince of Wales* just before her completion. The dock is now permanently flooded and is flanked by modern apartment buildings.

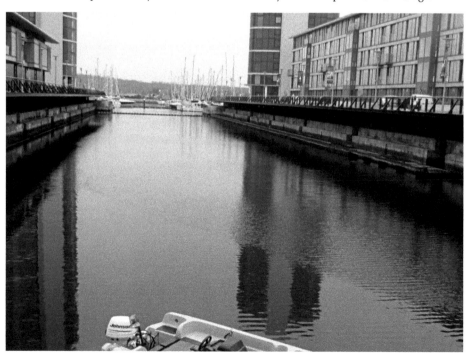

No. 1 Boiler Shop

This impressive building was moved from Woolwich Dockyard, where it had been a slip cover, and was re-erected at Chatham in 1876. This view dates from the 1960s and although slightly obscured by the buildings in the foreground, the Boiler Shop's landmark clock tower still stands out. Following the dockyard's closure, the building was completely renovated and converted into retail units to become the centrepiece of the dockside outlet complex. (*Photograph above: © Chatham Historic Dockyard Trust*)

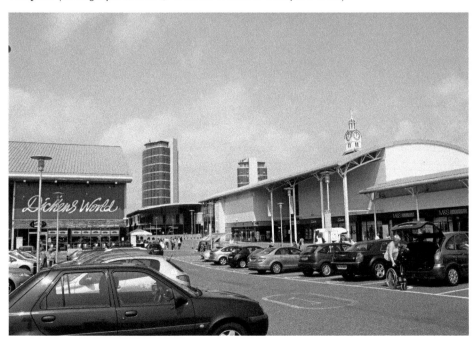

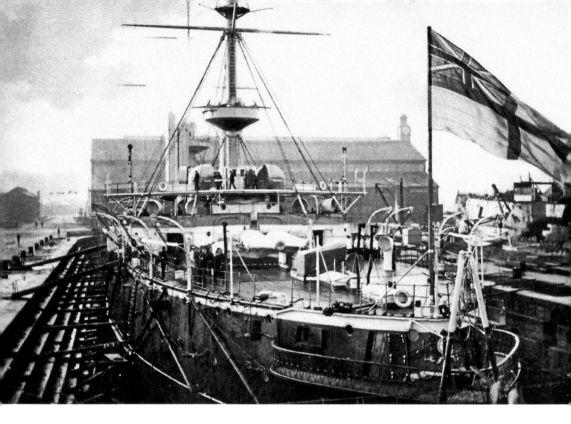

No. 8 Dock

This dock was completed in 1872. It is 414 feet long and is seen above in 1897 occupied with the battleship HMS *Empress of India* undergoing repairs. The No. 1 Boiler Shop provides an impressive backdrop to the view. The dock is now flooded, with the view of the boiler shop largely obscured by a modern residential apartment block.

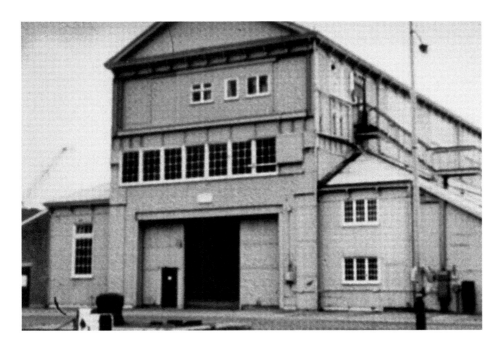

No. 8 Machine Shop I

Built in 1845 as a slip cover for Woolwich Dockyard, this structure was moved and re-erected at Chatham in 1875 following the Woolwich yard's closure. The building housed a foundry, a light plate shop and an electrical workshop. In the early 1900s an extension was added, connecting the shop to the nearby Ship & Trades building. When the Royal Navy vacated the dockyard, most of the surrounding buildings were demolished but the machine shop was preserved. (*Photograph above: © Chatham Historic Dockyard Trust*)

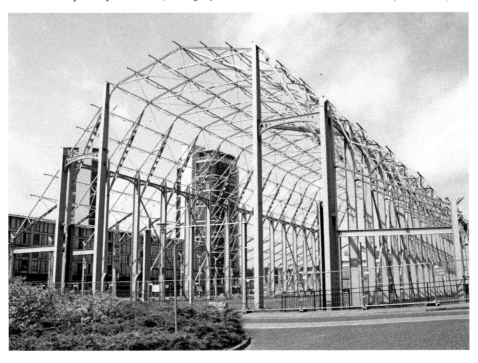

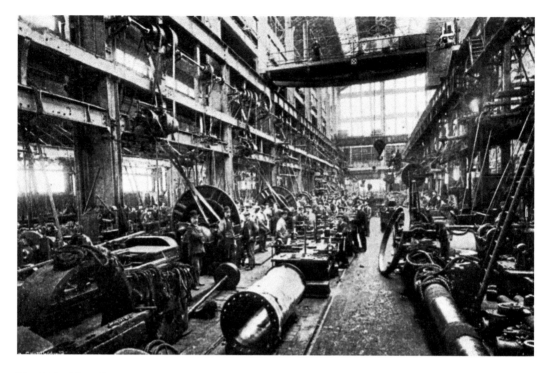

No. 8 Machine Shop II

Because of the historical significance of the Machine Shop, it survived demolition and its framework was granted Grade II listed status. Its corrugated cladding was severely damaged during 'The Great Storm', which hit Kent in the autumn of 1987 and was completely removed in the 1990s. The northern extension was demolished in 2000, leaving the skeletal structure we see today.

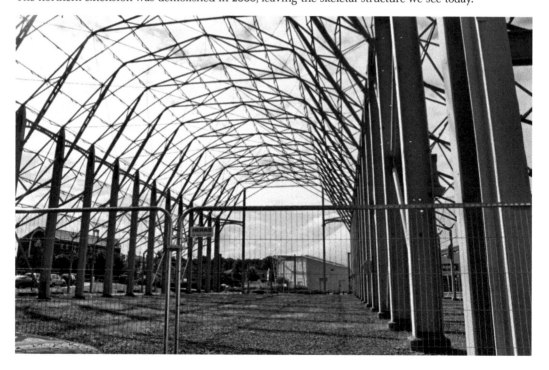

Pembroke Road

This view is from inside the yard in the early 1980s looking south towards Pembroke Gate. On the left is No. 3 Muster Station. In the centre the road crosses the dockyard railway and on the right the bell mast is visible, towering above the pattern shop. All these buildings have been demolished and the bell mast moved to a new site. The road now provides access to businesses at Chatham Maritime and homes on St Mary's Island. (*Photograph above: © Chatham Dockyard Historical Society*)

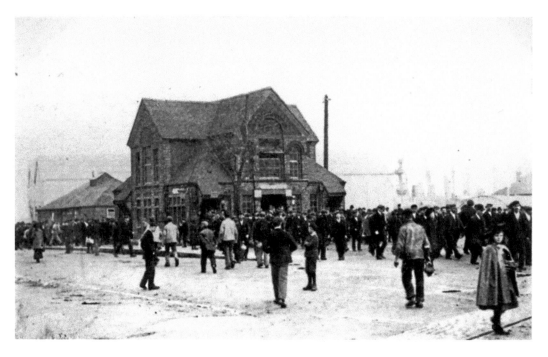

No. 3 Muster Station

Situated just inside Pembroke Gate, dockyard workers would report to the station each morning to get their chit allowing them to work for the day. The above photograph dates from the early 1900s. Later years would have seen the workers clocking in and out here. This building and the Pembroke Gate were both demolished when this part of the dockyard was redeveloped after the yard's closure.

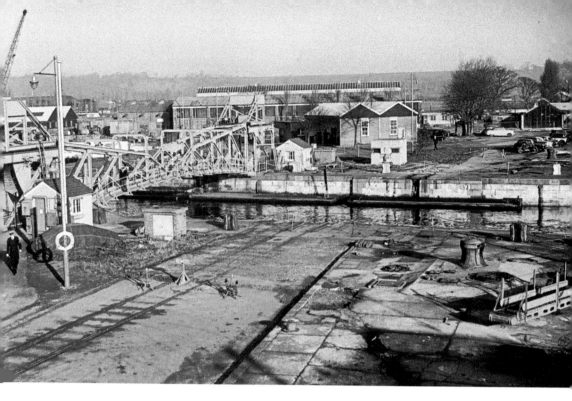

Bascule Bridge

To facilitate traffic access across them, bascule bridges were installed at the entrances to basins Nos 1 and 2. These could be raised for ships entering the basins. Seen above is the bridge at the entrance to No. 1 Basin in the 1950s. This has now been replaced with one of a modern design, allowing vehicles to travel to and from the residential development on St Mary's Island. It can still be raised for vessels passing between the basins. (*Photograph above: © 'The War & Peace Collection'*)

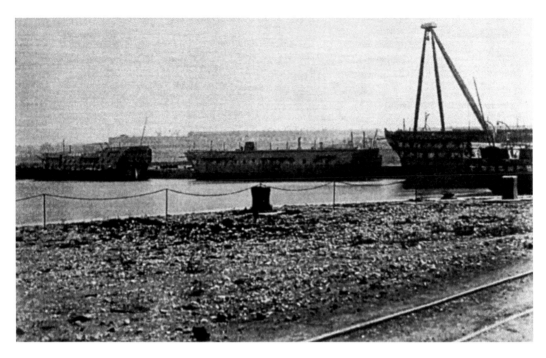

No. 2 Basin

Also known as the Factory Basin, No. 2 Basin covers an area of over 20 acres. Seen moored in the basin in 1874 awaiting scrapping or conversion are HMS *Severn*, HMS *Conqueror* and HMS *Vanguard*. The basin now hosts various water sports including sailing, windsurfing and canoeing, as well as supplying berths for the occasional goodwill visits of Royal Navy ships and other visiting vessels.

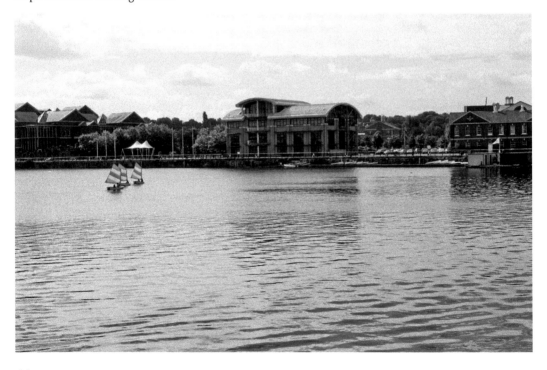

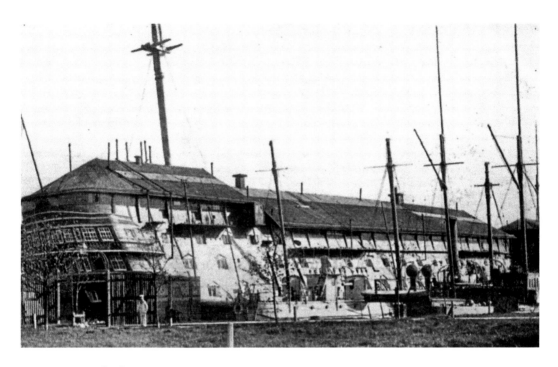

HMS *Pembroke* – No. 2 Basin

Until the completion of the new permanent barracks at Chatham in 1903, the crews of vessels held in the dockyard were accommodated in converted, obsolete warships known as 'hulks'. HMS *Pembroke,* formerly the 101-gun, first-rate battleship HMS *Duncan,* was one of three such vessels moored in the north-west corner of No. 2 Basin for this purpose. Now, in stark contrast to the spartan living conditions of the seamen in the hulks, luxury housing units overlook the area.

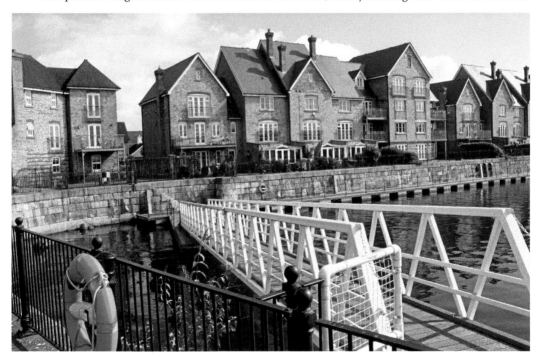

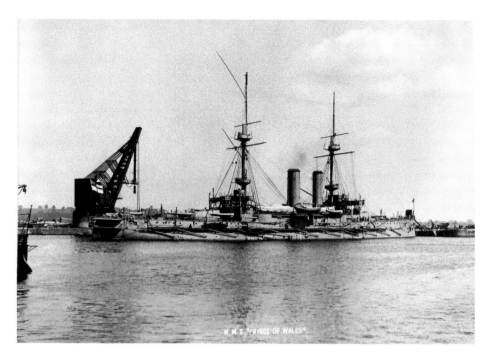

No. 3 Basin

Also known as the Fitting Out Basin, this is the easternmost and largest of Chatham's three basins, covering an area of over 27 acres. It was the home of No. 1 Crane, a 160-tonne fixed hoist, seen above around 1904, with HMS *Prince of Wales* moored alongside. The basin is now the site of Chatham Docks and moored here is the luxury yacht *Christina O*, once owned by Greek shipping tycoon Aristotle Onassis, who entertained Sir Winston Churchill on board.

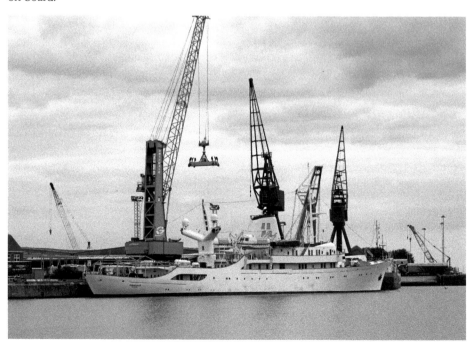

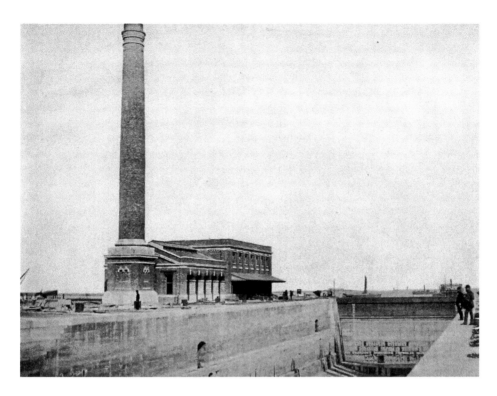

The Bulls Nose Locks

Located on the east side of No. 3 Basin, these twin locks provided the main entrances and exits to the dockyard. Constructed in the early 1880s, the locks were operated hydraulically by steam-powered pumps housed in the central pumping station. These pumps were converted to electricity in the 1920s and the chimney demolished some years later. The locks are still in use by Chatham Docks, with the pumping station looking much less impressive minus its magnificent chimney.

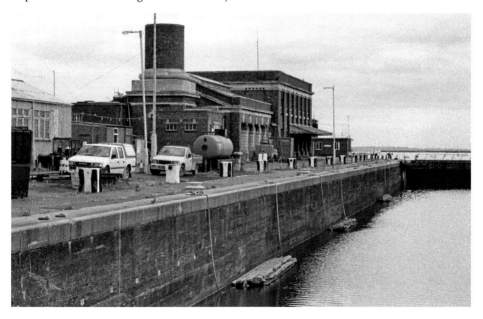

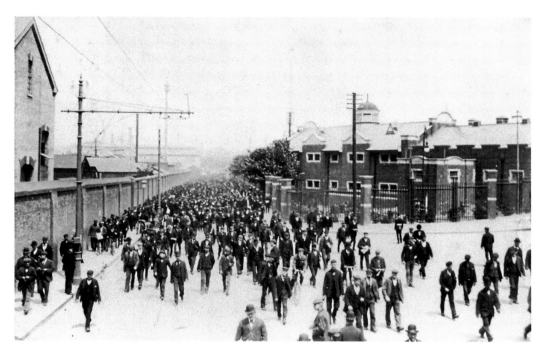

Dock Road

Most workers entered and left the dockyard through Pembroke Gate, situated at the end of Dock Road. At the end of the working day they would pour out of the gate into the road to board one of the many waiting trams or to walk home. On the right is the guardhouse of the Royal Naval Barracks, HMS *Pembroke*. Dock Road is now a busy dual carriageway linking Chatham town to the Medway Tunnel, Chatham Docks and Gillingham.

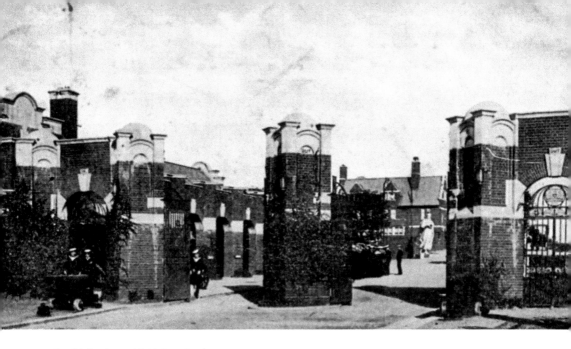

The Main Gate, HMS *Pembroke*

Designed by Sir Henry Pilkington and built in 1902, this was the main entrance to the Royal Naval Barracks off of Dock Road. The entrance originally consisted of five brick piers supporting four sets of wrought-iron gates, the guardhouse and gate lodge. The central pier was moved in 1990 to be re-erected inside the gateway, which now serves as the main entrance into the university campus.

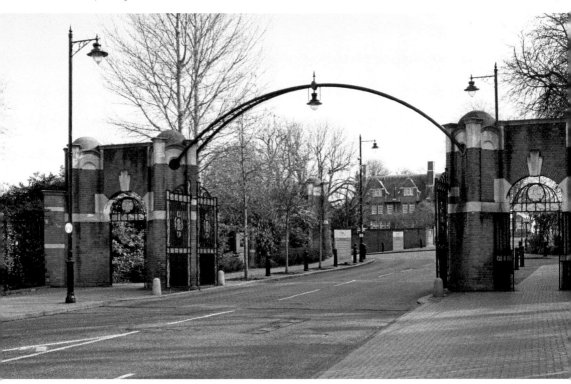

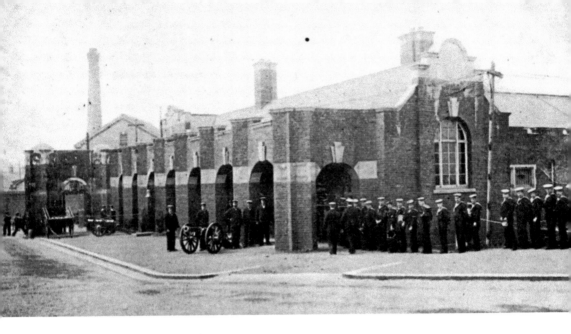

The Guard House, HMS *Pembroke*

Located just inside the Main Gate all visitors and personnel would report in and out of the barracks here. In the above postcard from 1908 ratings can be seen queuing at the guardhouse to check out on leave. The building was demolished following the Navy's departure and nothing remains of it today. In the far right of the recent photograph you can see the central pillar that has been relocated from the Main Gate.

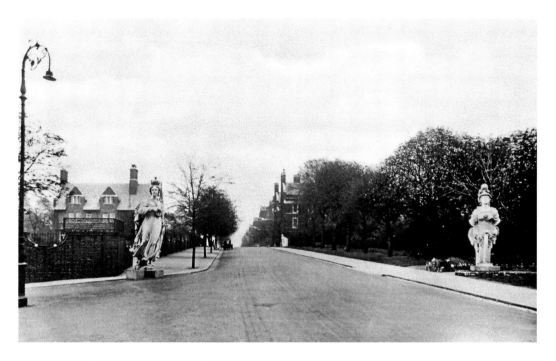

The Main Road, HMS *Pembroke*

This is the view that would have greeted you as you passed through the Main Gate and guardroom. The road, also known as Central Avenue, is seen above in the early 1900s, flanked with two ship's figureheads. The one on the left was from the battleship *Royal Adelaide* and the one on the right was from the battleship *Britannia*. Unfortunately the figureheads are no longer a feature of this view, which has otherwise hardly changed.

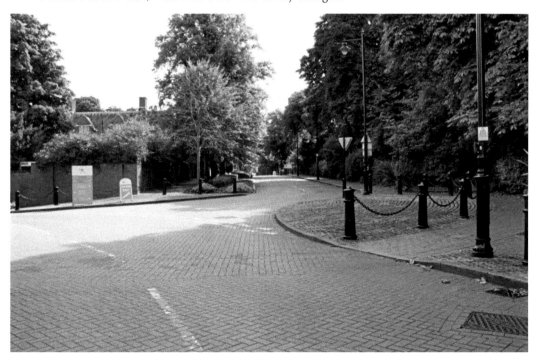

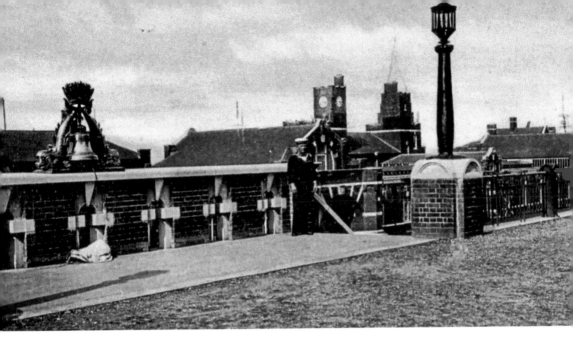

The Terrace, HMS *Pembroke*

Situated further along the Central Avenue is the terrace, which overlooks the full length of the Parade Ground. The steps down from here allowed access to the lower level from the barrack blocks. It also provided an ideal viewing point for guests and other spectators to watch the parades taking place below.

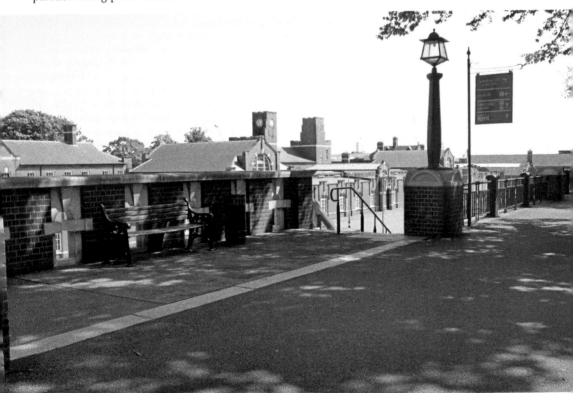

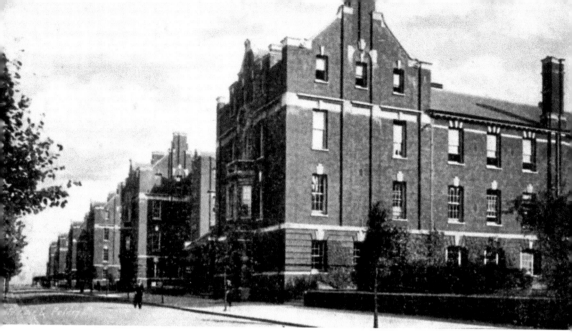

Men's Barracks, HMS *Pembroke*
Each named after a famous
admiral, there were originally
six barrack blocks sited along
Central Avenue, overlooking the
terrace. Each block could house
500 to 600 men, although many
more could be accommodated
in wartime. After the closure of
the barracks two of the blocks
were demolished. The four
that survived are now used
as teaching buildings by the
University of Kent and Medway
School of Pharmacy.

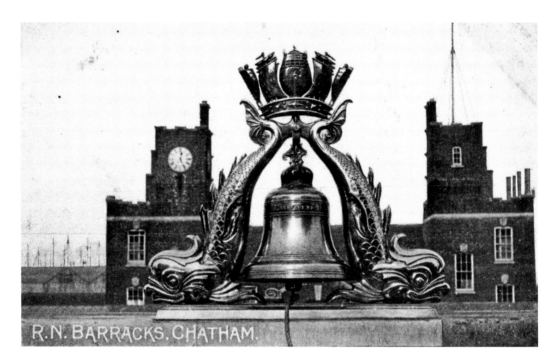

Barrack Bell, HMS *Pembroke*

One of three brass bells that once lined the terrace. It is mounted on the plinth of the Saluting Platform, overlooking the Parade Ground and looking towards the towers of the offices above the drill shed. They were used to indicate the time of day to the men at the barracks. I understand this particular bell was transferred to the training establishment, HMS *Ganges,* in Suffolk in 1961 but was 'lost' from there when it closed in 1976.

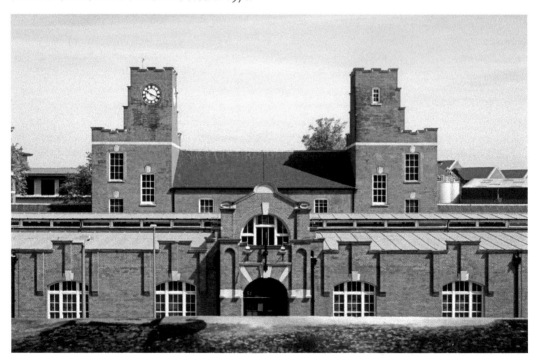

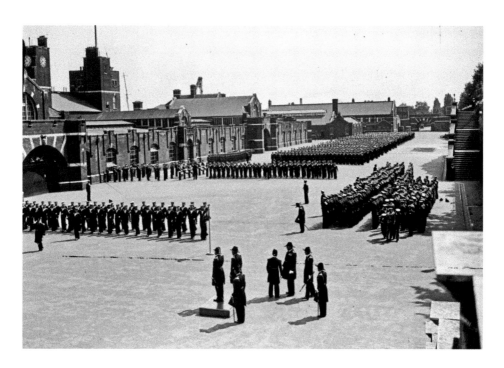

The Parade Ground (Looking East), HMS *Pembroke*

A view of a parade in the 1950s, looking towards the eastern end of the Parade Ground. From the shadows it's a hot summer's day and if you look carefully, at the right of the photograph, you can see one poor officer being carried off the ground, obviously feeling the effects of the heat. There were no such dramas on the ground when I took the more recent photograph! (*Photograph above: © 'The War & Peace Collection'*)

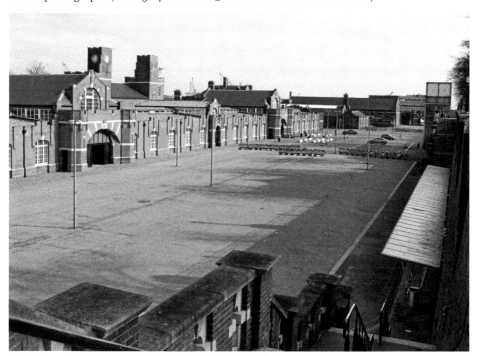

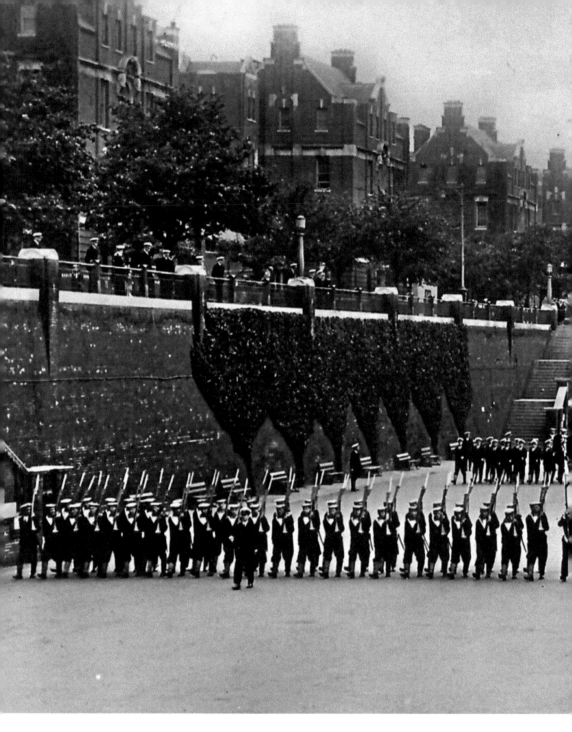

The Parade Ground (Looking West), HMS *Pembroke*
Another impressive parade, this one from the 1930s, by men of the Chatham Division. The Barrack Band can just be seen performing on the right. The terrace provides an ideal viewing point for those not involved in the parade. Now, instead of hosting grand parades, the ground is the university campus car park with a modern lift to provide easy access to and from the terrace.

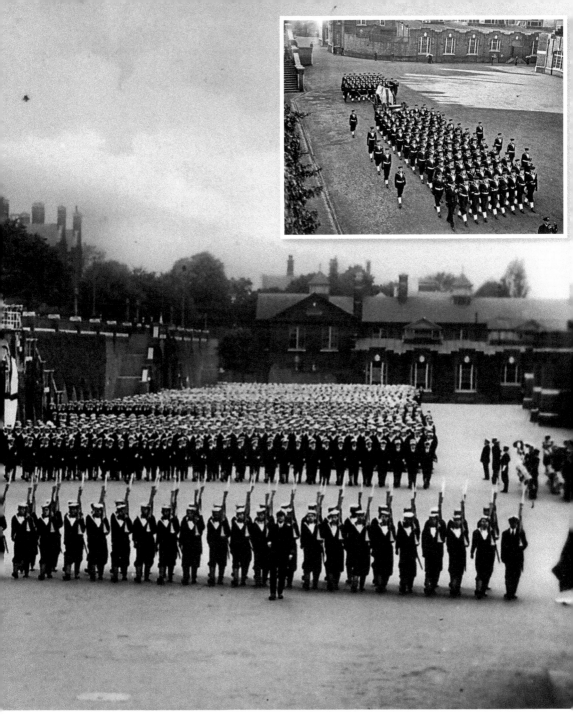

The inset shows the parade ground during a solemn royal rehearsal. When HM King George VI died in February 1952, preparations immediately began for his state funeral. The Royal Navy's Chatham Division was given the honour of providing the men to pull the gun carriage carrying the Royal coffin in procession through London, and rehearsals took place on the Parade Ground. Later that year, all the officers and men involved with the funeral received medals to commemorate their part played in it. (*Inset photograph above:* © *'The War & Peace Collection'*)

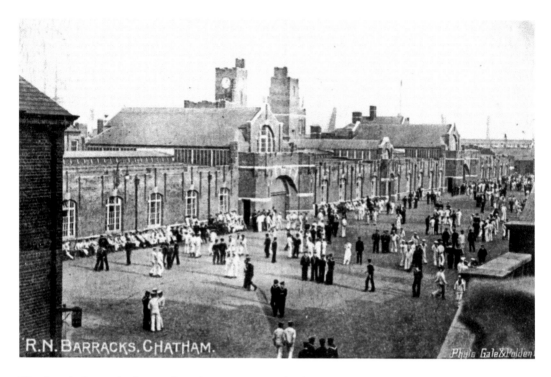

R.N. BARRACKS. CHATHAM.

Photo Gale&Polden.

The Parade Ground – Recreation Time – HMS *Pembroke*

The ground was not just used for parades and drilling. It was the ideal place for the men to relax and socialise with their fellow matelots, as can be seen here in this photograph from 1905. A more recent photograph of the view, taken on a Sunday, shows an empty parade ground. During the week this area is occupied with students on their way to and from the Drill Hall Library.

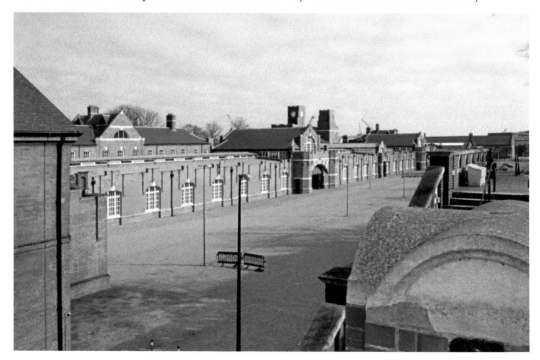

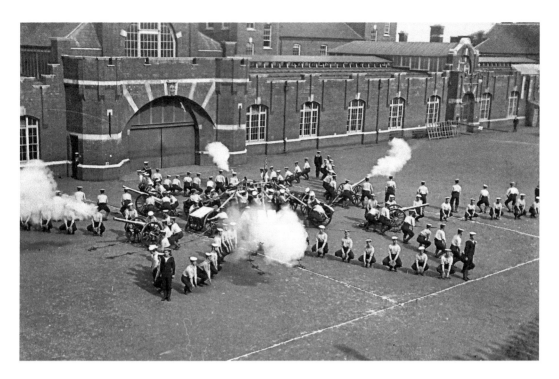

The Drill Shed I

Built in solid brick with a quarter-inch thick glass roof, the drill shed was completed in 1902 to provide the barracks with an indoor area for exercise and training. It also served as an overflow barracks and storehouse. A Field Gun Drill is seen above taking place outside the shed in 1905. The building now serves the campus as the Drill Hall Library and is used by students seven days a week during term time.

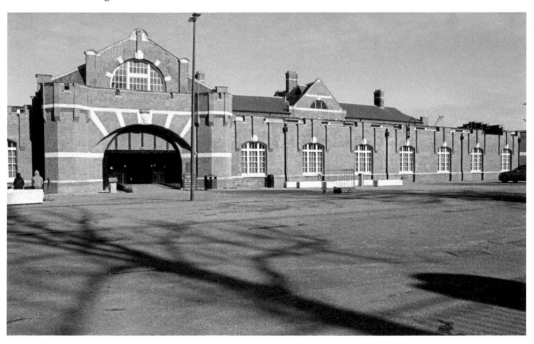

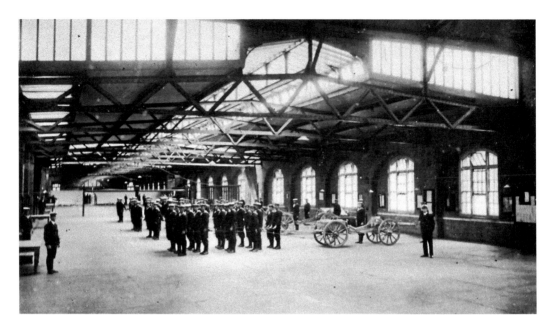

The Drill Shed II

On the night of the 3 September 1917, while it was being used as an overflow barrack, the shed was struck by two bombs dropped by a German Gotha bomber. They fell through the roof, showering the 900 men sleeping below with deadly shards of glass, and then exploded. The final death toll was 126, with many more badly injured. A plaque commemorating the raid is on display in what is now the Drill Hall Library. (*Photograph below: © Chris Hall*)

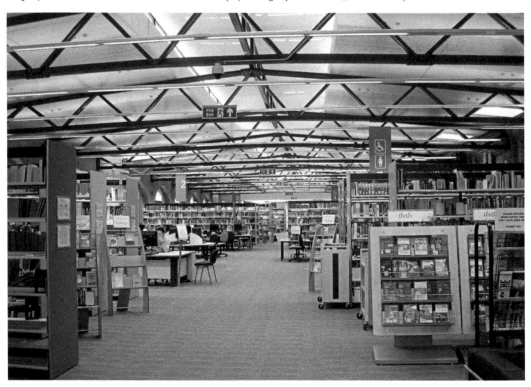

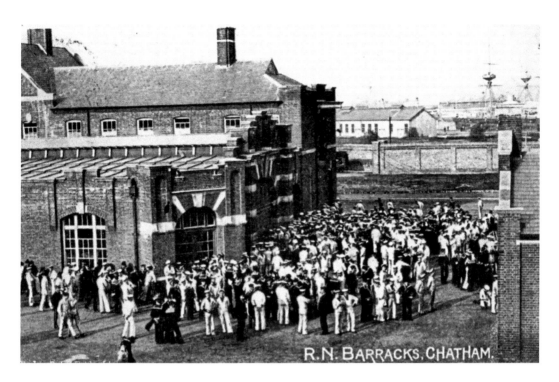

R.N. BARRACKS, CHATHAM.

Pay Day, HMS *Pembroke*

The men at HMS *Pembroke* were paid fortnightly. They would queue up in the drill shed to receive their wages from the pay office and then congregate outside, no doubt debating just which local hostelry they should visit that night to spend a good part of their wages in! If they were congregating at the same spot now they would be in serious trouble for blocking the entrance to the campus car park!

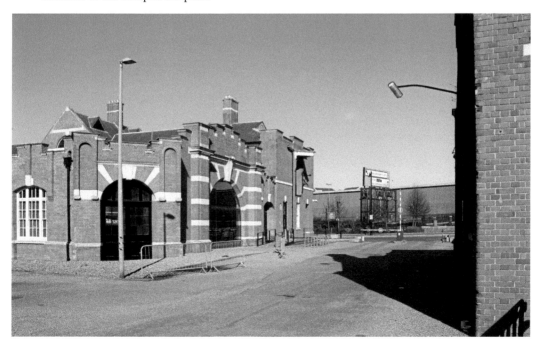

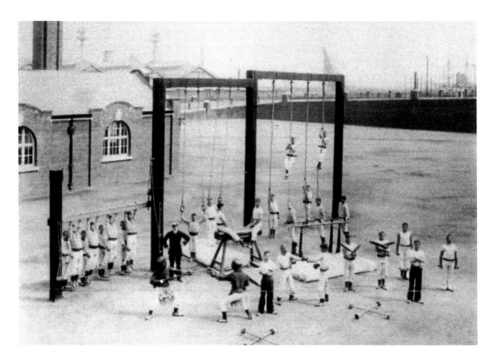

Gymnastics, HMS *Pembroke*

Keeping the men fit while in the barracks was, and still is, an important feature of naval life, and regular gymnastic exercises played an important part in this. Prior to the building of the gymnasium seen in the more recent photograph, these exercises often took place outside on the parade ground. The cranes in No. 3 Basin of the dockyard can also be seen in the background of both photographs.

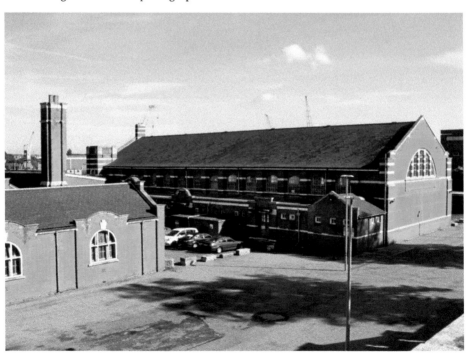

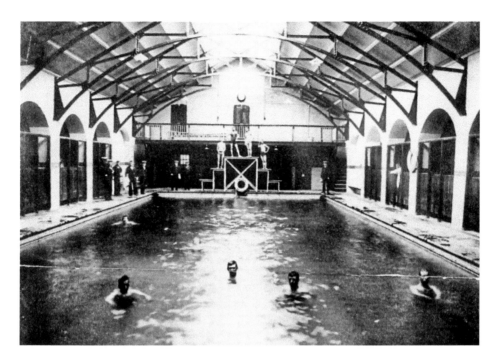

Swimming Pool Building, HMS *Pembroke*

Every naval recruit had to be able to swim before they went to sea. A swimming pool building was constructed at *Pembroke* and was completed when the barracks opened in 1903. As well as for lessons it was also used for competitive and recreational swimming. The building also included a skittle alley for the serviceman to use in their recreation time. The building now lays empty and awaiting refurbishment.

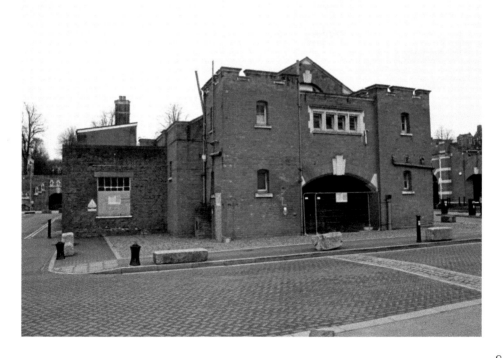

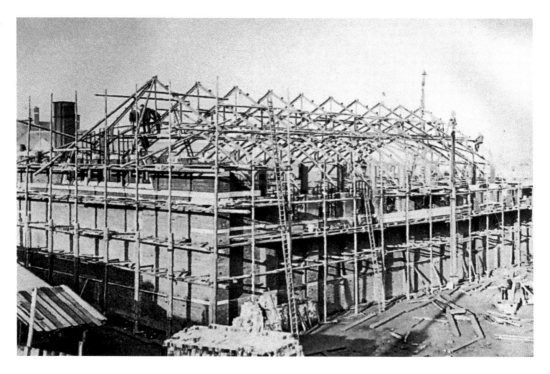

Gymnasium, HMS *Pembroke*

This gymnasium was a slightly later addition to the barracks. It is seen here under construction in 1908. When completed it provided a purpose-built indoor facility, with the latest gym equipment, to keep the servicemen at peak fitness all the year around. It is still in use today, providing Medway Campus with a modern fitness centre and indoor sports facilities.

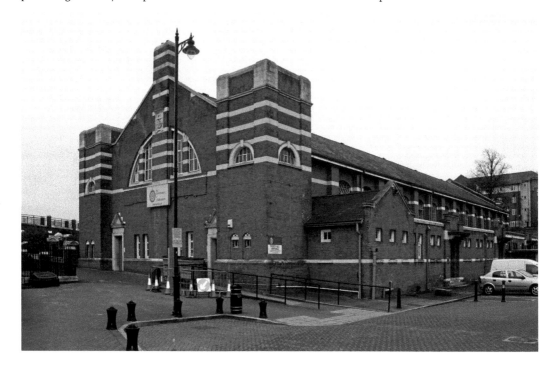

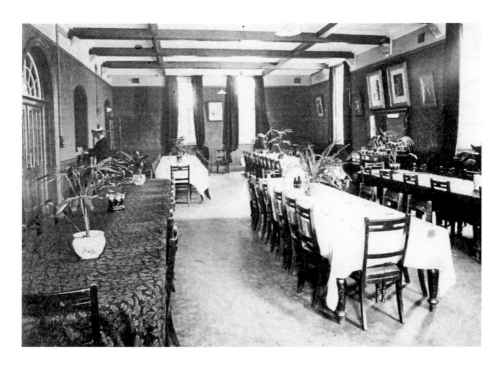

Warrant Officers' Mess, HMS *Pembroke*

In the Royal Navy the term 'warrant officer' dates from when ships were captained by noblemen, few of whom had experience of seamanship. Instead they relied heavily on crew with certain specialist skills such as boatswains and gunners, who were ranked as officers by warrant and were issued by the monarch rather than by commission. At HMS *Pembroke* the warrant officers had their own mess at the western end of the barracks. The building now houses the campus bar.

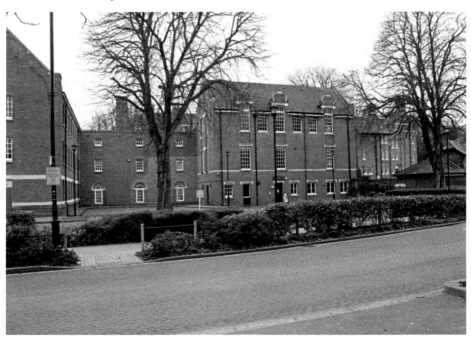

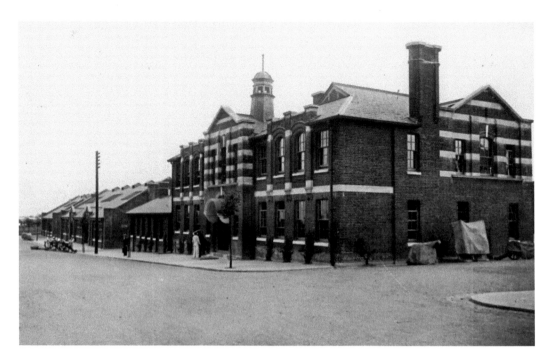

Gunnery School, HMS _Pembroke_

When the barracks opened, the Nore Command's Gunnery School moved here from Sheerness. The school originally consisted of several buildings, including a huge steam-powered 'dummy' gun turret. The school closed in 1958 but was reopened again in April 1959 as the Royal Navy Supply School. The only school building remaining today is the former lecture rooms and offices, now in use by the University of Kent. (_Photograph above: © Chatham Historical Dockyard Trust_)

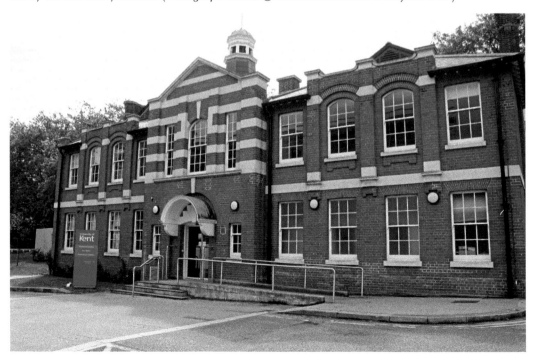

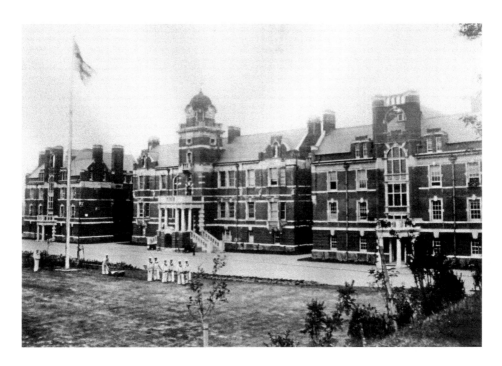

Officers' Quarters, HMS *Pembroke*

The Officers' Quarters are probably the most recognisable and photographed group of buildings in the barracks. Designed by Sir Henry Pilkington and built in 1901, they housed accommodation and mess facilities for the commissioned officers. The grounds opposite contained a rose garden and croquet lawn, as well as both hard and grass tennis courts for use in leisure time. The buildings are now used as office accommodation and as a wedding venue.

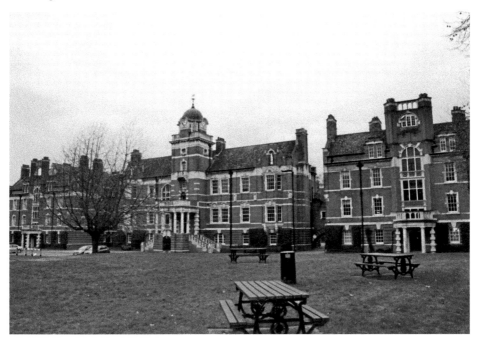

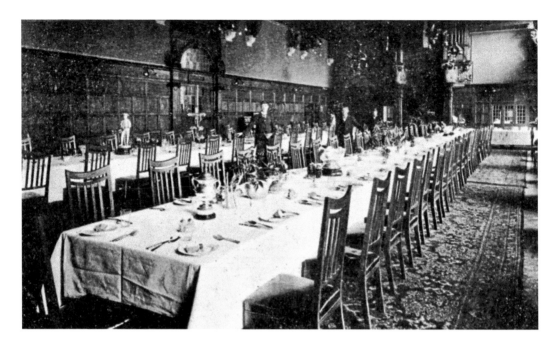

Wardroom, HMS _Pembroke_

This room is located in the central block of the Officers' Quarters and was used for dining and recreation by commissioned officers in the barracks above the rank of midshipman. With its vaulted-beam ceiling, minstrels' gallery, oak-panelled walls and huge inglenook fireplace, it is probably the grandest room in the barracks. It now serves as an impressive venue for weddings and receptions catering for up to 180 guests. (*Photograph below: © Chris Hall*)

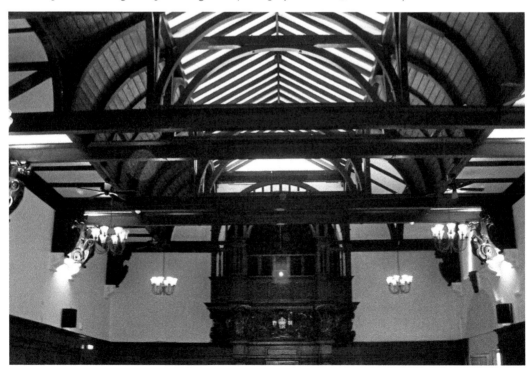

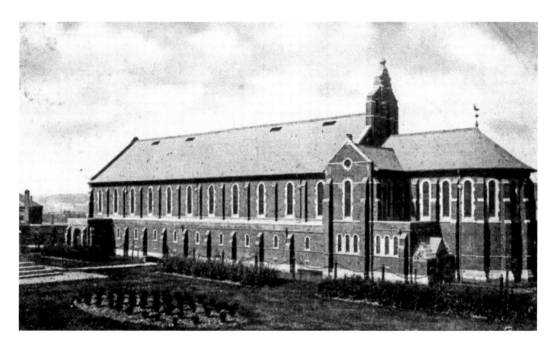

St George's Barrack Church, HMS *Pembroke*
Built in 1905/06 to provide a place of worship for the men of the barracks, the church was dedicated by the Bishop of Rochester, John Harmer, on 19 December 1906. It contains various naval memorials, including a stained-glass window commemorating all Chatham-based ships that were lost during the Second World War. Now managed by Medway Council as St George's Centre, it remains a naval memorial centre while also being available for hire for indoor events.

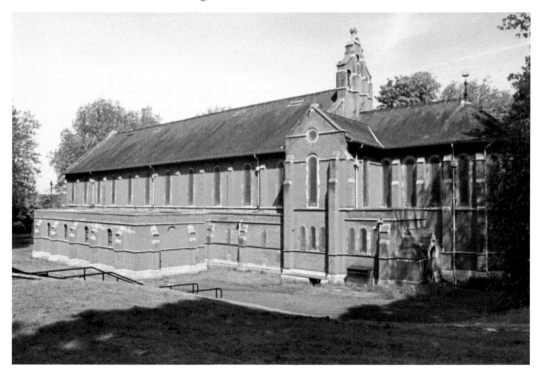

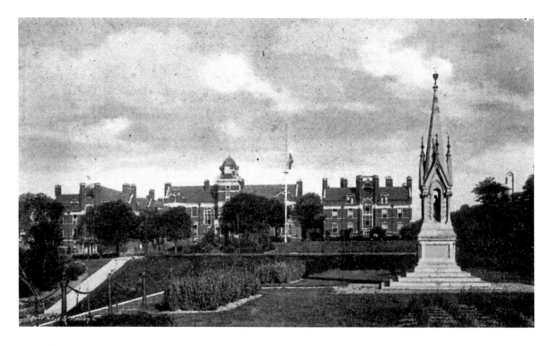

French Prisoners of War Memorial, HMS *Pembroke*

In December 1904, the remains of 711 French Napoleonic prisoners of war who had died while being held on prison ships on the Medway were moved from their cemetery on St Mary's Island to a site adjacent to the barrack church. A memorial was designed with the approval of the French Government and erected above the site. In 1991, the remains of a further 362 prisoners were discovered on St Mary's Island, which were also subsequently interred here.

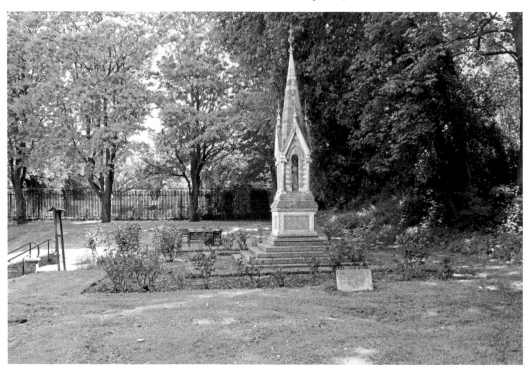

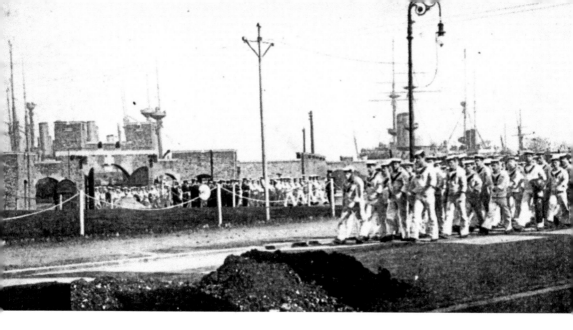

Dockyard Barrack Gate, HMS *Pembroke*
Built to provide direct access from the barracks into the dockyard, it is flanked on each side by a guard post. The post on the left was manned by dockyard police, who checked entry from the barracks into the dockyard, and the post on the right was manned by Royal Navy guards, who checked entry in the opposite direction. These two guard posts are all that remains of the gateway today.

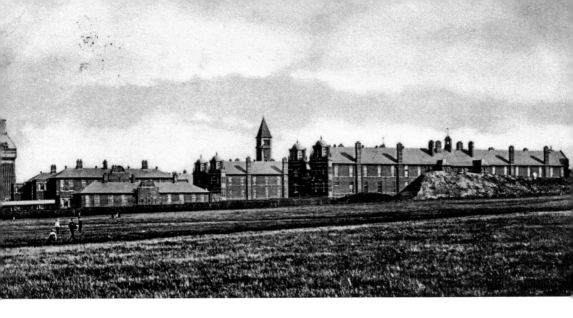

The Royal Naval Hospital

To serve the new naval barracks a hospital was built on the Great Lines. Opened by King Edward VII in 1905, he carried out the ceremony using a gold key presented to him in a silver casket. He then toured the hospital's wards, theatres and kitchens. The hospital was handed over to the NHS in 1961 and has since undergone extensive expansion and alterations, as demonstrated by comparing the similar views now and from 1905.

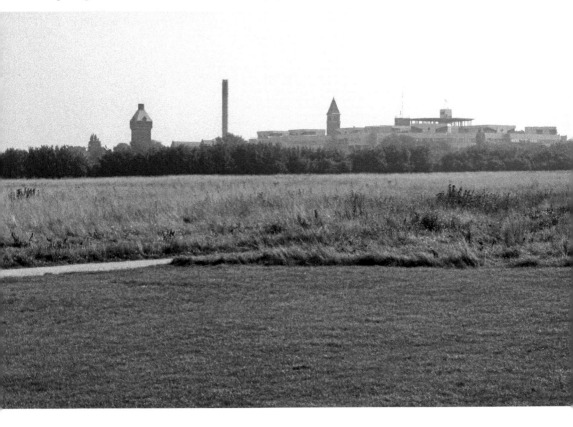

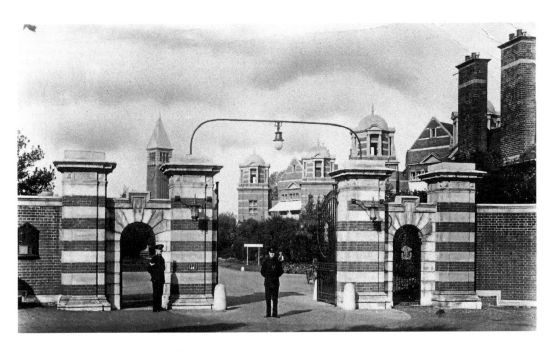

The Royal Naval Hospital Main Gate

Being a naval establishment, the hospital had a guarded entrance, similar to the one at the barracks. Situated just off of Windmill Road it comprised one vehicular and two pedestrian gateways divided by brick pillars. A police lodge stood just inside the entrance. The hospital is now the NHS Medway Maritime Hospital, with this entrance still serving as the main access to the site but minus the ornate gates and police guards.

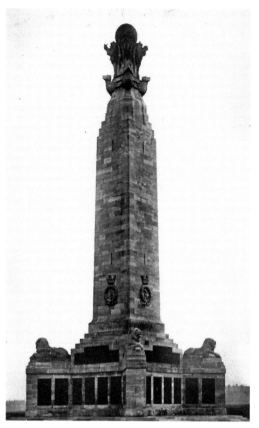

The Chatham Royal Navy War Memorial
The memorial, situated on the Great Lines, was unveiled by the Prince of Wales in 1924 to commemorate Chatham-based servicemen lost at sea during the First World War. The names of over 8,500 sailors were cast on bronze panels and fixed to the buttresses of the monument. After the Second World War, the memorial was extended to include surrounding walls, which contained fifty bronze panels, with the names of 10,112 naval dead who perished at sea in that conflict.

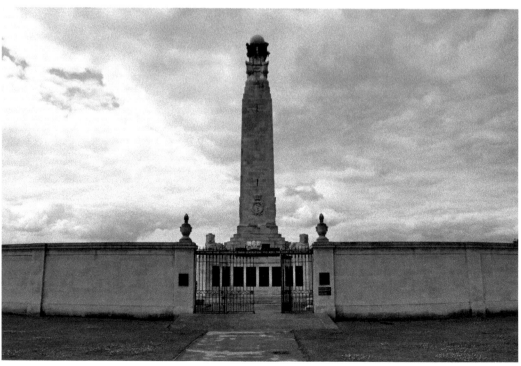